# DIGITAL VIDEO Production Cookbook

First edition for the United States, its territories and dependencies,
Central and South America, and Canada published in 2006 by O'Reilly Media, Inc.

O'Reilly Media, Inc.
1005 Gravenstein Highway North
Sebastopol, CA 95472
USA
www.oreilly.com

Editorial Director: Edie Freedman, O'Reilly Media
Cover Designer: Edie Freedman, O'Reilly Media

O'Reilly books may be purchased for educational, business, or sales promotional use.
For more information, contact our corporate/institutional sales department:
(800) 998-9938 or corporate@oreilly.com

Downloadable image files of the examples in this book can be found online at:
http://www.oreilly.com/catalog/digvidprod/

International Standard Book No. 0-596-10031-0

This book was conceived by:
ILEX, Cambridge, England
www.ilex-press.com

ILEX Editorial, Lewes:
Publisher: Alastair Campbell
Executive Publisher: Sophie Collins
Creative Director: Peter Bridgewater
Managing Editor: Tom Mugridge
Editor: Kylie Johnston
Art Director: Tony Seddon
Designer: Simon Goggin
Junior Designer: Jane Waterhouse

ILEX Research, Cambridge:
Development Art Director: Graham Davis
Technical Art Director: Nicholas Rowland

Manufactured in China

9 8 7 6 5 4 3 2 1

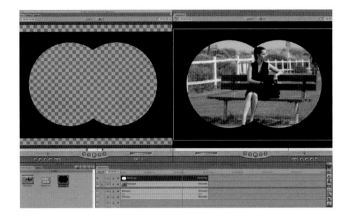

# DIGITAL VIDEO Production Cookbook

Chris Kenworthy

# Contents

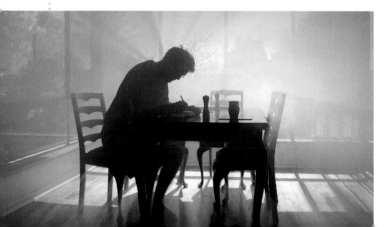

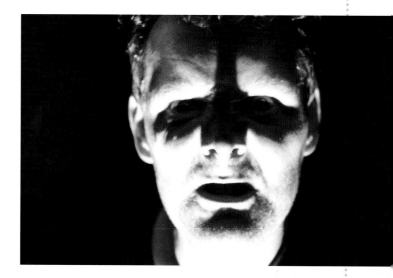

# Introduction

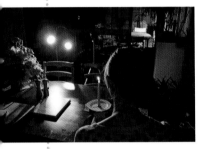

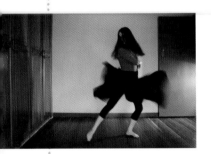

If you're making your first short film or a low-budget feature, this book will help to increase the visual and dramatic impact of all your shots. Many new directors are frustrated to find that despite having a vivid imagination, the films they make don't quite live up to their original vision. By using the techniques in this book, you can create stunning shots that take your work to another level.

Most of these techniques cost little or nothing to achieve, once you've bought or borrowed the essential equipment. And, thankfully, most of the methods described in this book demand only minimal effort and can make a huge improvement to your shots.

This book is not designed for complete beginners, although the novice would learn a lot by attempting the projects shown here. Ideally, you should be confident with your video camera—in other words, have read and understood the manual. You may not be an expert at using the camera's manual settings, but you should have a basic grasp of how it works.

You don't need to be an experienced director to use this book, but it helps if you have some familiarity with the way that shots are set up, filmed, and put together. When it comes to editing, you should have a reasonable level of confidence with your software in order to achieve a basic edit. This book will guide you through more advanced editing and visual effects techniques.

Although many of these techniques may look like cheap shortcuts, don't underestimate their power. Exactly the same techniques are used on Hollywood sets. In the professional movie world, time is money,

and if there's a quick, cheap way to get the result, that's how it will be done. You don't need a massive crew, a bank of lights, or a director's chair to get good shots. So long as the end result looks good on screen, it doesn't matter how you get the shot.

One area that a book such as this can't cover is acting performance. We concentrate on showing you the practical techniques required to achieve great-looking shots, but it's up to you to inspire and direct your actors to deliver a strong performance. Without that, all the technique in the world will just look like showmanship.

Whether you're using friends, student actors, or true professionals, look after your talent. Practice these techniques thoroughly before you perform the actual shoot, so that your actors aren't waiting around unnecessarily.

You can tackle each chapter of the book as a project, or simply pick the sections you need for a film you're working on. Ultimately, it's vitally important that you take these techniques and do something new with them. All directors borrow and learn from other directors, but to be truly creative, you should use these techniques as starting points for creating your own work. A simple way to start doing this is by combining two or more techniques in a single shot.

Whatever you do with these techniques, remember that you are always telling a story. No matter how surreal, ambitious, visually memorable, or original your ideas, the images you create should contribute to the story you're trying to tell.

# Getting Started

## Camera and tripod

You can use any video camera to make movies, but the better your camera, the better your shots will be. If you can, use a 3-CCD MiniDV camera, such as the Sony VX2100. This camera has a built-in zoom lens, and a wide-angle lens can be attached. Most importantly, shutter speed, exposure, and White Balance can be controlled manually. Your camera should be Firewire-enabled. Firewire is also known as IEEE1394 or iLink, and enables you to connect your camera directly to a computer for editing.

If you have more money available, the new HDV cameras, such as the Sony HDR-FX1, are ideal for making movies. With a resolution four times better than DV cameras, they produce ultra-clear images.

Your tripod should be sturdy, with a fluid head, to enable you to make smooth camera moves. You will use your tripod so often it's worth investing in a good one.

## The movie light

A good movie light is very important. You can usually borrow or hire a camera, whereas movie lights are more difficult to source.

Movie lights—or in industry-speak, "lamps"—differ from ordinary lights, because they are more powerful, and they have barn doors attached to the front, so you can stop the light from hitting a particular wall or ceiling. A Fresnel-type light (pictured right), can be focused down to a tight beam, or spread out into a wide beam. Your light should come with a sturdy, tripod-based stand.

## Sound equipment

Good sound makes all the difference to your final film. Never try to shoot dialogue scenes with the camera's onboard microphone. Instead, you can buy a boom pole and microphone, which enables you to place the microphone close to the actor's mouth, just out of shot. Bad sound ruins a great shot, so it's worth the extra trouble to achieve good sound.

You should also wear headphones while shooting, so that you can hear the actors' performance through the microphone.

## Editing software

You might only spend a few hours shooting your film, but you will spend many days editing, adding effects, and completing the titles. This is why it's vital to have really good editing software. You can complete many of the techniques in this book with free software such as iMovie or Avid Free DV, but to get the most out of it, you should use software such as Final Cut Express or Final Cut Pro for the Macintosh; or if you own a PC rather than a Mac, a more upmarket version of Avid is the best choice.

If you are using a PC, make sure you have a good one. Although IBM-compatible PCs can easily do the job (when sufficient peripherals are added), Apple Macs are the computer of choice for moviemaking. You can plug in your cameras and start editing. Although a top-of-the-range Mac can be expensive, the new Mac Mini or iMac G5 makes the Mac an affordable computer for editing movies.

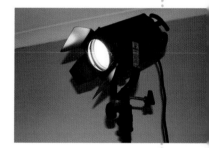

# LIGHTING EFFECTS

# Colored Light

You don't need expensive lighting equipment to create colored lighting effects. With a little ingenuity, you can color your scenes to change the mood or create a more interesting look.

For many years, movies have been lit by lamps with colored gels. If you want to create a sunset look, you use a yellow gel on the lamp. For a cold afternoon, a blue gel will do the trick. But gels are expensive, delicate, and difficult to use accurately. Also, they can halve the light output of your lamp, which means that you need twice as many lamps to light your set. The techniques described here can give you the same effect as a lighting gel, without the difficulties or expense.

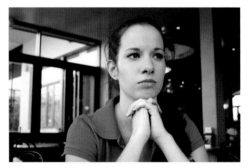

**2** One of the simplest ways to change the mood of a shot is to give the overall image a tint. Without trying to color the light on set, you can change everything with your editing software. Here, a greenish hue has been added to the clip with the Color Correction filter. All good editing software gives you this option.

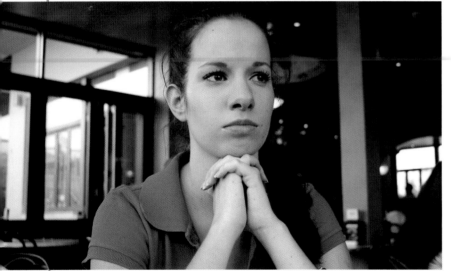

**1** In a perfectly lit shot, the white light reflected on the glass looks white, skin tones look natural, and shadowed areas are almost colorless. Also, the actor is lit more strongly than the background to make her stand out. While this is a perfectly lit shot, it doesn't have much atmosphere.

**3** Sometimes, the simpler the method, the better the results. Although this image shows a really cheap solution—hanging a brightly colored towel near to the actor's face—the results are excellent. If there's a quick and cheap way to get the result you want, you can be certain it's what they do in Hollywood, too.

**4** The actor is standing with her back to the sun, against a shadowed wall. Without the towel, the shadow on her face would be gray and colorless. The reflected color from the towel adds life to the shot and gives the scene some depth.

**5** Brightly colored paper or poster board can add a sharp, contrasting spread of color. Hold the card close to the actor, and then frame your shot so that the card is out of view.

**6** The person holding the colored paper must stand absolutely still, or the color will move visibly on your actor's face. Alternatively, use a stand with some clips to hold it in place.

**7** Complex lighting can be created quite simply by using sunlight. Translucent green plastic has been secured over a glass window, which leads into a darkened room where the shoot will take place.

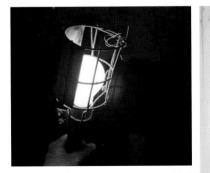

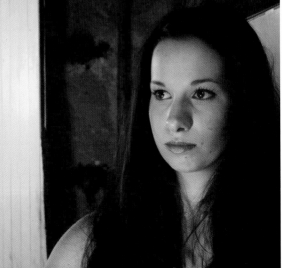

**9** The result is a beautiful mix of white outdoor light, green-colored light, and the glow on the actor's face. This mix of colors adds depth and interest to a scene, and makes it look much more professional. It's an excellent way to make an ordinary location, such as your own house, seem like a real movie set.

**8** The actor is lit from below with nothing more than a handheld bulb.

# Wall Ripples

Some of the best effects are the ones that are not immediately obvious, but which have a subliminal effect on the audience. Ripples of light on the wall can add a realistic effect to an underground cave scene, or bring a futuristic look to a backdrop in a science-fiction movie. This technique was used to great effect in Ridley Scott's *Blade Runner*.

Although this looks like a big-budget effect, you can achieve good results with nothing more than a child's inflatable paddling pool and some careful lighting. It does take time to set up this effect, so don't rush.

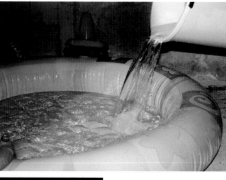

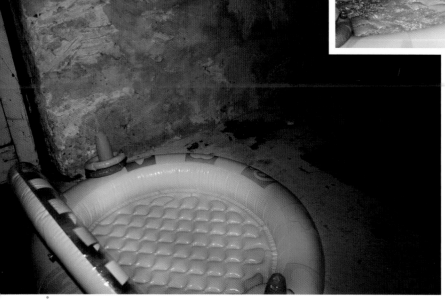

**1** You don't have to shoot your cave scene in a real cavern—any rough-looking wall will do. This effect is easiest to achieve if you shoot at night, to guard against stray lighting entering the room. Place the pool—or any other relatively large, shallow container—close to the wall that you want to illuminate.

**2** Fill the pool with water. Whenever you work with water and electricity in the same place, it's essential that they don't come into contact. Set up your lighting so that it can't possibly fall into the water, and keep cables well above ground.

**3** Whether you use a movie light, such as a Fresnel, or an ordinary work light, angle the beam down toward the surface of the water. You should see a single patch of light reflected on the wall.

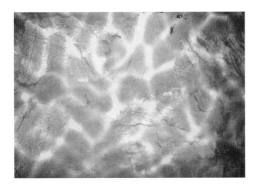

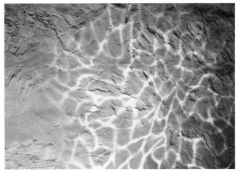

**4** To get the ripple effect, agitate the water. You can do this by pushing down carefully on the edges of the pool. The patch of light will spread out into beautiful ripples.

**5** Experiment with different setups, setting the light higher, lower, or at a distance from the water. Try out multiple combinations to vary the effects, so that you can select from wide, blurry ripples or narrow, bright streaks of light.

**6** Once you are ready, bring your actor onto the set and light the scene so that she can be seen clearly without casting a shadow on the wall. You might find that the main light gives off enough of a glow to light her.

**7** Have your actor stand in front of the pool, unless you want the light ripples to spread over her as well as the wall in the background. When you load the finished shot into your editing software, you can adjust the colors to look more like water and less like artificial light.

# Using a Lighting Card

When you see footage of a Hollywood movie being made, you get the impression that every scene requires a bank of huge lights. Although lights are used extensively, one of the best-kept secrets is that some scenes are lit with nothing more than sunlight and a piece of white card.

Even when you use lights, a piece of white card can help solve many problems by filling in shadows. Any bright, white card will work, but foamcore board (available from art supply stores) is light and durable.

 **1** When you shoot outside in bright sunlight, dark shadows on the face can obscure the actor's features. Here, the shadows are exaggerated because of the hat, but the same shadows would be visible from the nose and in the eye sockets.

**2** By holding a white card under the actor's face, and bouncing some of the sunlight back up, you can fill in the shadows.

**3** Although the shadows remain visible, they have been softened and brightened by the light. This quick solution is far better than trying to erect a gigantic shade to protect the actor from the sun.

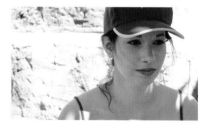

 **4** The opposite problem can be just as easily solved. When your actor sits in shadow against a bright, sunny background, the result is a silhouette. Although you can increase the exposure level in your camera, this might make the whole scene look too bright.

**5** Instead, place a white card near the actor in direct sunlight. If you can't place the card in direct sunlight you'll need to point an electric light at the card, or use a mirror to reflect sunlight onto it. Be sure to use a color correction gel on the lamp.

**6** The result is an evenly lit face that captures the brightness of the day, without looking overexposed.

# Mirror Light

On a professional movie set, most of the time is spent setting up the lights. Good lighting makes the difference between an ordinary and a stunning scene.

In some cases, you can add layers of light to improve the look of a scene. Bands of bright light, directed by flexible mirrors, make your movie look like a professional production. Your audience will appreciate the added richness and depth of the scene.

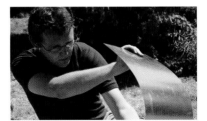

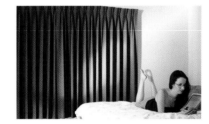

**1** The basic scene is reasonably well lit, and the actor is shown distinctly against the background, but the image isn't very interesting. Although we can see the room behind her, it is too dull to make this an atmospheric scene.

**2** Sheets of thin, flexible metal, such as aluminum, can be purchased cheaply. You can point a bright light at them or simply go outside into the sunshine, and reflect a beam of light inside.

**3** You should see a pool of light appear on the wall. Check that this shows up well in the camera, and adjust the exposure if required.

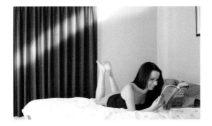

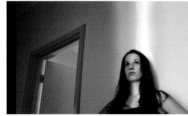

**4** The next step is to bend the mirror. This will change the pool of light into a bright band.

**5** You usually get the best result if you arc the light, like a rainbow, between two points in the room. The light will cut from the bottom left of the frame to the corner of the room, adding a sense of space to the scene. When you are about to shoot a take, the mirror has to stay still until you call "Cut."

**6** Although flexible mirrors tempt you to make arcs and curves of light, don't underestimate the beauty of a simple, straight band of light. In this shot the actor is standing in an area where the light changes from shadow to bright. The light from the mirror makes the shot more dramatic.

# Using Shadows for Realism

Household objects such as Venetian blinds and pieces of cardboard can be used to cast shadows and patterns onto your scene. This technique can be used to suggest a setting that isn't really there (such as a tree outside a window), or simply to make a shot more atmospheric.

In the movie world, an object that casts a patterned shadow in this way is called a "cookie." Directors have utilized this technique for years as a way to make an ordinary room look special or to create the illusion of a location, for the minimum amount of effort.

**1** Cut rough holes in a piece of cardboard, making sure there's enough cardboard left for the cookie to hold together easily.

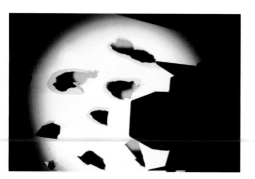

**2** Ask an assistant to hold the cookie in front of your lamp, or better still, secure it on a stand to minimize movement. Be careful not to put it too close to the lamp—you don't want to ignite the cardboard by mistake.

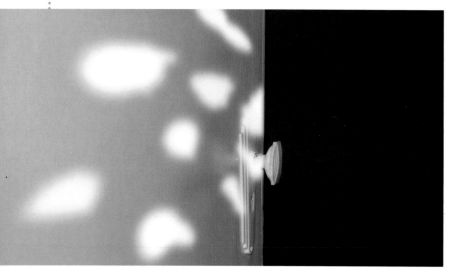

**3** A cookie can produce a range of effects, depending, for example, on how close you place it to the lamp, how far the lamp is from the wall, etc. In this instance the final look is quite surreal, but the same cookie could be used to create the impression of light filtering through foliage, by moving it further away from the lamp to create softer shadows.

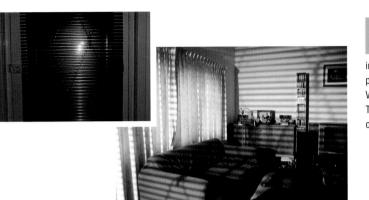

**4** Start looking out for objects on set that can be employed as cookies. This saves you making your own, and gives you a quick, easy way to improve your lighting setup in an instant. Here, a lamp is placed outside the room, so that the light glows through the Venetian blinds, casting bands of light across the whole set. This effect is very atmospheric and is a staple of the thriller or TV detective series.

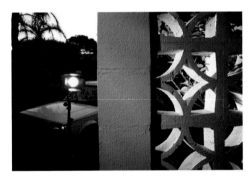

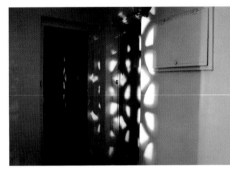

**5** Most movies include shots of people answering the door—it's such an overused scene that you need to find a way to make it more interesting. A brilliant pattern of light can be created with the judicious placement of your lamp.

**6** Sometimes there's no substitute for reality. Here, a real tree branch is held in front of a lamp. When the character approaches the window (perhaps in an attempt to break in), the viewer believes that the actor is hiding in its shadow.

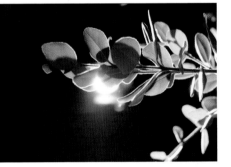

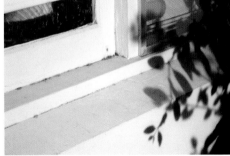

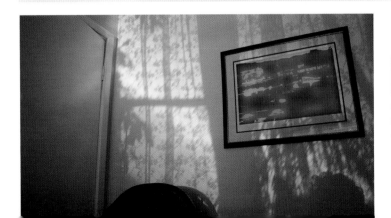

**7** In some shots, you might want to have some shadow movement—for example, to show the gently fanning movement of palm fronds outside a window. You can achieve this by making a cookie with some movable elements. Shine a bright line through a net curtain and the fronds of a small palm tree, and you have a realistic pattern cast on the wall.

# Candlelight

Candlelight is one of the most atmospheric lighting effects in the movies. The best way to get a good image is to add more artificial light than can actually be produced by a candle. Although the result isn't quite authentic, your audience will recognize and accept the effect, and it is far better than using actual light from a candle.

With a little preparation, you can cast flickering, double shadows that have the realism of candlelight, but the brightness of artificial light. When the character is brightly lit, the audience never suspects artificial lighting. Only when the lighting is bad does the audience think about your setups—so add enough light to make your subject clear. Also, be sure to remember that the contrast between light and dark is much more pronounced on camera than to the naked eye. If it looks quite dark when you're shooting it, then it will probably be very dark when you come to view the footage—in real life, your eyes automatically adjust for the differences in illumination between the light and the shadows.

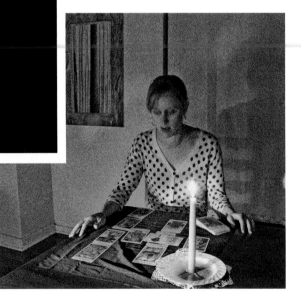

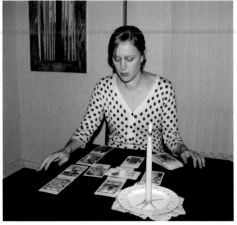

 Although most video cameras appear to work quite well with the light from one or more candles, the image only looks good in the viewfinder. When viewed on a large screen you'll find that it's either too dark or far too grainy.

**2** To light the scene, set up your shot and rehearse with a standard overhead light. As you add and test lights, keep turning the overhead light off to see the results. Always turn the light back on when you change a lighting setup, rather than struggle in the dark.

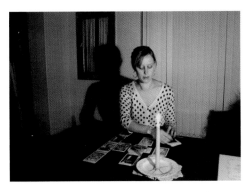

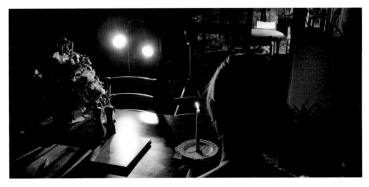

**3** Light the candle and set up a lamp out of frame, pointed toward the actor. This will add the required shadow. Test the shot by looking through the camera, but also see what the result looks like with the naked eye. Your own vision will be more accurate than the camera's tiny viewfinder.

**4** You should set the lights up so that the bulbs are at the same height as the candle, and pointing directly toward the wall behind. In most shots you aim to keep shadows off the wall, but in this case you want to keep them because that's what candlelight does—it casts shadows.

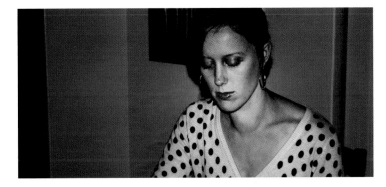

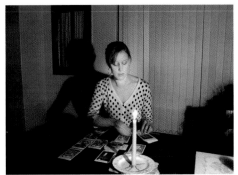

**5** Your main aim, however, is to ensure that the actor's face is clear, and that the room feels dark around her. Point your lamp at the actor's face. You may find you can enhance the result by pointing a flashlight directly at the actor.

**6** When you think there's enough light on the actor's face, use the camera's manual exposure adjustment. Adjust the exposure so that the face is the brightest part of the image. You should be able to see all the details clearly. The room will appear to darken around your actor, and possibly look underexposed.

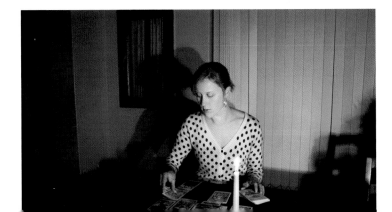

**7** An even more realistic effect is achieved by adding two lights, a small distance apart, to cast two shadows. While not technically realistic, this looks authentic on screen. You can move the lights by hand throughout the shot to create a gentle flicker. A subtle movement will create the illusion of flickering candlelight. Alternatively, getting your assistant to wave a hand in the path of the light beam also works well.

# Backlighting

Watch almost any movie by Steven Spielberg, and you'll see that the air in the background is usually filled with light. Many TV shows use the same technique, to lend an ordinary room more atmosphere. Although quite extreme, this effect is used so frequently that audiences accept it as a realistic look.

You can create this look with nothing more than a smoke machine from a party-hire shop, and some careful lighting. In a matter of minutes you can make your scene look like an expensively lit movie set.

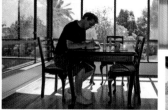

**1** The smoke machine will take a few minutes to warm up, so plug it into the wall socket before you need the smoke. If you plan to use this effect often, it's worth purchasing your own machine, but they only cost a few dollars to hire from party supply stores.

**2** The essential rule with backlighting is that you should light the smoke from behind. In other words, there should always be bright light directed toward the camera, through the smoke.

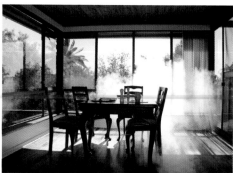

**3** When you pump the smoke out, it forms clouds, which need to be dispersed evenly through the room. You can achieve this by waving your arms or using a sheet of cardboard to stir the air. Be careful to maintain the same level of smoke from shot to shot, especially if you're shooting over several hours.

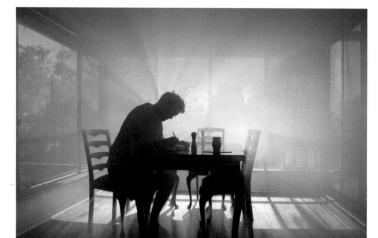

**4** The finished result looks like a classic Spielberg shot—atmospheric and mystical. Suddenly your front room feels like a movie location. The actor is in silhouette here, but you can light him normally.

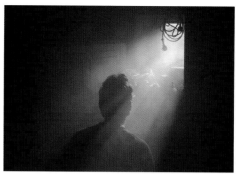

**5** An ordinary basement can be made to look like a suitably scary horror-film set with a little backlighting. Here, a strong light has been placed outside the main window.

**6** With the basement's overhead light turned off and smoke spread through the room, the light casts dusty beams through the window.

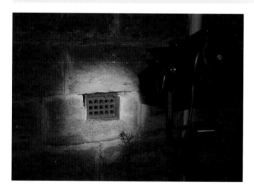

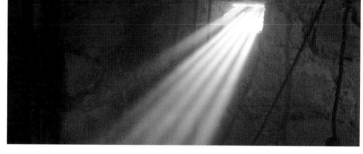

**7** You can also shine your light through holes in the wall, grates, or grids.

**8** The results look superb, and can make the most ordinary locations look dramatic.

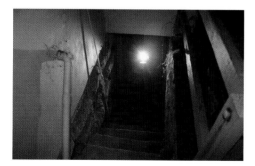

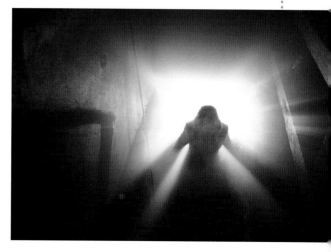

**10** As your actor climbs the stairs, moving beams of light wrap around her arms and body as she moves. This technique is used all the time in horror and science-fiction movies.

**9** Smoke allows you to position a light behind your actor, pointing up at the camera. This kind of lighting is usually impossible because the light stand and cables are visible, but using backlighting, the smoke hides them.

# Practical Lights

Any light that appears on screen, such as a floor lamp, lantern, or flashlight, is called a "practical" light, and it completely changes the look and feel of a scene. When you're setting up a scene, ask yourself whether it could be improved by including a practical light.

This attention to detail makes your film stand out, and adds realism to your shots. Practical lights are easy to use, and, because you can use household lamps, they cost little or nothing.

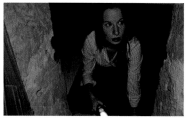

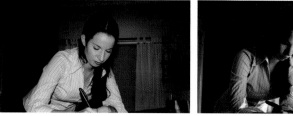

 **1** When you add a practical light to your scene, you can usually remove other lighting. Readjust your exposure so that you can get the shot with just the practical lamp.

**2** Whether this is a tender moment or one of real drama, the standard lighting setup is just a bit too standard. By framing the actor more to the left, and balancing the empty space with a practical lamp, a more attractive look is created. This glow on her face is softer, and there are more interesting shadows. There's also a glow on the table, and the lamp makes the composition more satisfying.

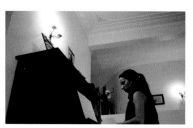

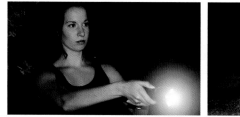

 **3** If there are unshaded light fittings on the wall, switch them on and see what effect they create. You might find that they sometimes flare into overexposure unless you add lots of extra light to the scene. This overexposure can make a scene feel more cozy.

**4** If you use a handheld flashlight, don't rely on its power to actually light the surroundings. In this sequence, the flashlight itself shows up perfectly well, but doesn't cast a strong enough beam to light up the tree. Instead, point a strong movie light into the darkness, and shoot that instead.

# Faking a Complex Lighting Setup

A simple trick that makes use of the White Balance feature enables you to produce a sophisticated-looking scene without having to create a complex lighting setup. Normally, you use the White Balance to make white light look white, but you can also use it to change the appearance of an entire scene.

One useful effect of this technique is to make a scene look like a winter evening. Try to shoot during the hours of daylight, even if it's getting dark.

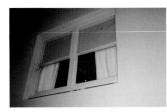

**1** Shooting from outside and looking in can be problematic. If you light the wall well, the interior may look too dark. But if you turn the lights on inside, the wall may start to look too dark or the colors may seem unrealistic.

**2** When you use the manual White Balance on your camera, you normally point the camera at a white surface and then press the White Balance button. This is because light is rarely white: daylight is blue and indoor light is yellow. If you are using fluorescent bulbs, the light will be green. The White Balance adjusts the colors in-camera in the same way that your eyes do, so that everything appears to be lit with white light. Here, we play a trick on the camera. Instead of using a white card, hold a bright yellow card in front of the camera and press the White Balance button. The card should turn white in the viewfinder.

 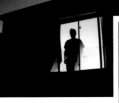  

**3** Pointing your camera back at the scene, you should see the outdoor light turn a soft blue, and the indoor light warming up— very effective when you're trying to reproduce twilight or a wintry atmosphere.

**4** The same technique can be used when the sunlight has faded, leaving only the residue of daylight. The effect produces a deep blue sky, and rich, glowing indoor light.

**5** If you are filming during the day, you can use a blue card to set the White Balance. Hold the card so it fills the viewfinder without being in shadow, and press the White Balance button.

**6** Using a blue card makes the white light turn golden, so that a daylight scene looks like sunset. This approach produces deeper, richer colors in your scene that you could only otherwise achieve by using Color Correction filters in your software.

# Silhouettes

Silhouettes are effective because they create a strong sense of contrast, particularly if the silhouette is black against bright colors. Used sparingly, they add drama and visual flair to your work, and are easy to create with your DV camera.

Make sure you're familiar with the manual exposure controls on your camera before you attempt these shots. It's easy to practice without actors or crew, so run a few tests before using this technique for real.

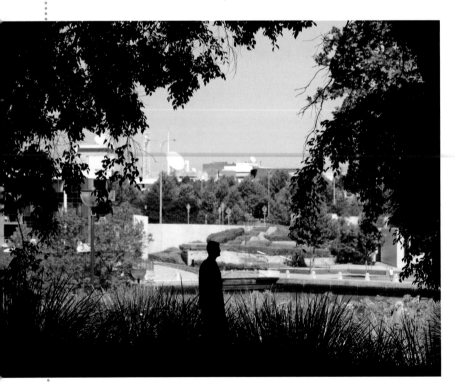

 **1** Some silhouettes occur quite naturally. Here, because the actor is beneath the trees, the autoexposure creates a strong silhouette against the bright background.

**2** On dull days, it takes a little extra work to create a silhouette. Using autoexposure, you'll find that everything looks well-lit.

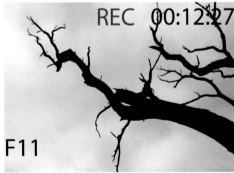

**3** To create a silhouette, close down the iris in your camera, perhaps all the way to f11. On some cameras, the shutter speed will automatically slow to prevent a silhouette from occurring—so if you need to, switch off the automatic shutter speed.

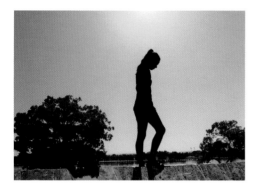

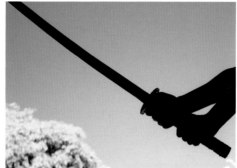

**4** This silhouette shot—with the actor standing in front of the sun—isn't always easy to create. Set on automatic, your camera may compensate for the uneven lighting, and bring up the actor's exposure. Keep it on manual, allowing the background to overexpose if necessary to get the foreground in silhouette. The less reflected light there is on your actor, the better.

**5** When setting up a silhouette, it can be tempting to clear the background frame to make the silhouette really show up. As this example shows, a completely clear frame isn't always best. The color provided by the tree makes the sword show up even more clearly against the sky.

**6** An unusual approach is to make the middle distance a silhouette while keeping the foreground and background well lit; this creates a bright, clear image. The actor is sitting in the shadow of the tree, and has been lit artificially.

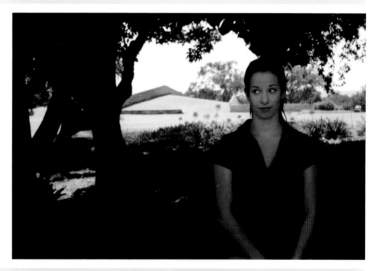

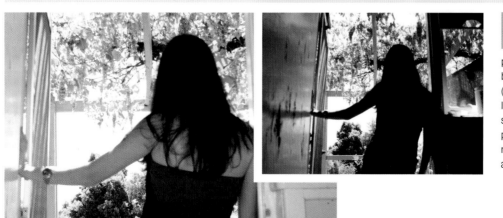

**7** Partial silhouettes can be just as powerful as a completely black shape. The first shot (where the actor is fully lit) looks too complex. In the second version, where she's partially silhouetted, the resulting contrast creates a much stronger image.

# Light Sweep

Although most directors know that moving the camera adds interest to a shot, few know the value of moving your lights during a scene. By moving the lights, you can create the impression of something bright moving past a window, just out of sight.

With the right sound effects, this technique can create the impression of a spaceship landing outside, or a ghostly apparition approaching the door. Take care to move your lights gently to avoid blowing a bulb, and protect your hands, because all lamps get very hot.

**1** Position your lamp outside, pointing toward a door. Use a door that has holes in it—keyholes, for example, or where door handles are missing. These gaps allow light into the room. Put the light on a stand with wheels or mount it on a dolly, so you can easily move it. You can also hand-hold it, which will allow for a larger range of motion—but it may be harder to keep the movement smooth.

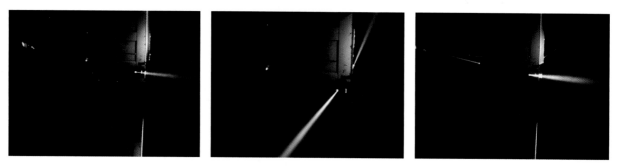

**2** Inside the room, use a smoke machine to inject a slight mist into the air. Open the door a fraction, so that a tiny amount of light illuminates the room. Have your assistant experiment with moving the light slowly down and to the side, pointing it up, down, or straight ahead to get the effect you want. Rays of light will filter through the room, creating the effect of a ghostly presence.

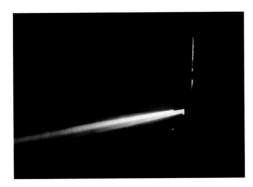

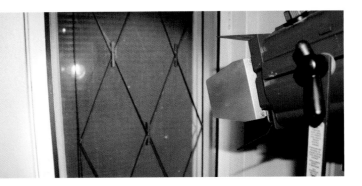

**3** It's important that the audience see the door and walls when the shot begins. Toward the end of the shot, however, you might want to move the lamp further to one side, so all of the light is concentrated into a single beam. Be sure that no additional light spills through other gaps in the doorjamb. The sudden darkness that results will increase the dramatic tension.

**4** An even simpler approach creates the strong illusion of something bright—perhaps a UFO— moving past the window. Place your light outside the door or window, pointing through the Venetian blinds.

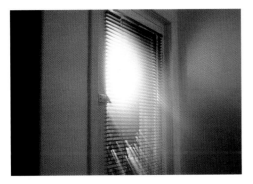

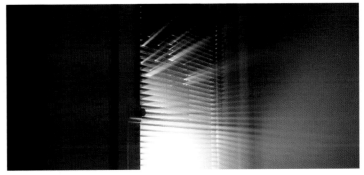

**5** Inject some mist to the air with your smoke machine. Begin the shot with your lamp positioned high up, pointing downward. Putting the lamp on a stand for this shot will help create a slow, smooth motion.

**6** As the shot continues, move the lamp down and level it off, so that it is pointing straight into the room.

**7** Lower the lamp to the floor as you rotate the beam upward. This will create the illusion that either something large and bright is landing outside or that the windows are being penetrated by searchlights. This is an effect that was used to great effect in Steven Spielberg's *ET* some years ago, and it remains convincing today.

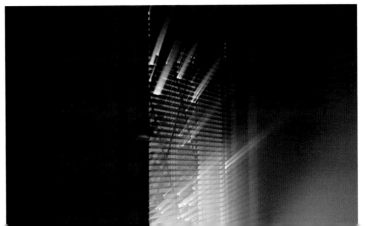

# Horror Lighting

By changing the angle and placement of lights, you can turn an everyday scene into something horrifying. While these techniques are ideal for horror, they can also be used to add suspense or an air of mystery to an otherwise ordinary scene.

Many people assume that darkness alone creates a sense of horror, but that genre works best when light and dark are cleverly contrasted. Darkness can be used to obscure or disguise part of the image, and it is this "missing part" that creates a sense of fear.

**1** Most lighting stands don't allow the light to be positioned any lower than hip height. For good horror lighting, particularly of a character, you need to place the light down low, pointing upward. Find a way to secure your light safely on the floor, so that it shines toward the ceiling.

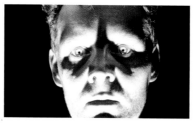

**2** Often you will need to bounce the light off walls or cover the lights with something in order to soften the glow. For horror, aim the light straight up into the actor's face. This technique will cast unusual shadows and distort expressions, creating a sense of menace.

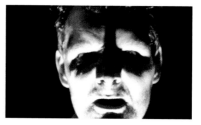

**3** Menace is one thing, but for real horror, your actor should move forward even further, so the eyes are hidden from the light entirely. The sharp contrast makes the face look distorted and strange, with the actor's teeth and eyes obscured in shadow.

**4** What you can't see is often more scary than what you can see. Here the wall is brightly lit, but the interior remains dark. The lamp was placed close to the exterior wall and angled toward the doorway.

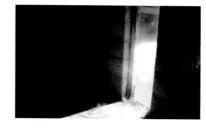

**5** The opposite effect: the viewer looks into a surreal, bright, glowing room. To create this illusion, use a smoke machine with a single, bright light. Lights are used to create a sense of contrast.

**6** For the best results, ensure that you adjust the manual iris controls correctly. If you leave the settings on automatic, the camera will try to adjust the light in the scene and fill in the dark spaces.

# Table Glow

Whenever you see a restaurant or dinner table scene in a movie, the table almost appears to glow, giving all the characters a beautiful, even light. This looks like a complex setup, but it can be achieved with judicious use of a single light.

While the table appears to glow brightly, you don't need to use lots of lamps, because the effect you are looking for is contrast. By making the background dark, the table and your characters stand out against it. Your actors are never lit directly, but bathe in the glow from a white tablecloth.

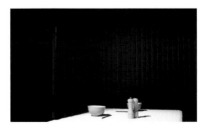

**1** If you have rigging equipment, hang your light over the table, pointing directly downward. Otherwise, take the light stand as close to the table as possible, without interfering with the shot, and position the light high, directed downward at the table.

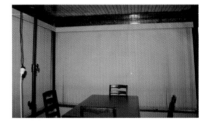

**2** Use a very clean, white bed sheet or other piece of white material as an underlay for the tablecloth. The camera will be low in the final shot, so you don't need to worry how the edges of the sheet look.

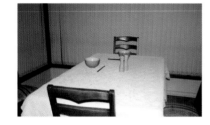

**3** Place a white tablecloth over the table. If your cloth is made of lace, that's fine, the sheet underneath will act as a reflector. You need as much white as possible on the table, so use props sparingly.

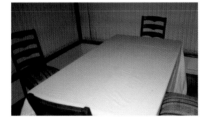

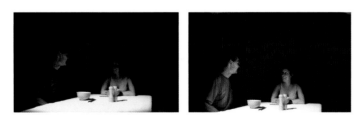

**4** Turn on your movie light, and turn off all other lights. Adjust your light so there is no spillage onto chairs or walls. The table should stand out brightly against the background.

**5** Set up your camera so that it's at table height, looking across at the actors. Put the actors into position and check that they are not directly hit by the lamplight. Your actors may need to lean forward to be illuminated by some of the glow of the table. Your camera will automatically adjust to the brightness of the table, as shown in the first image here. This makes the actors' faces too dark. Use the manual controls to brighten the actors' faces. This will have the combined effect of making their faces clearly visible, and will add extra glow to the table.

# Storytelling with Shadow

Filmmakers usually try to hide shadows. While the real world is filled with shadows, they don't always look good in-camera. A common mistake is to put a lot of light on the subject in the foreground, which then creates overly strong shadows on the wall behind. The solution is to position your lights high up, pointing downward, so the shadow is hidden from view.

Sometimes, though, shadows can be used to change the mood of a shot, or even to tell the story. Shadows are mysterious and tantalizing because they hint at the story, rather than tell it directly.

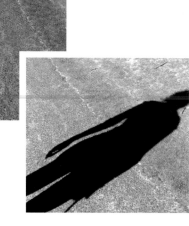

**1** Strong sunlight can be used to create a perfectly good shadow. At midday, you'll find that shadows are too short to be useful, and at sunset they are too long. At any other time, strong sunlight creates a sharp, powerful shadow. Imagine a sequence where the hero rides his bicycle out of shot. The camera could tilt down to the tarmac as the bike's wheel goes out of view. Then, after just a moment, the shadow of a person walking moves into the frame. This is a chilling way to imply that somebody is following the hero.

**2** To create good shadows indoors, work at night or block out as much light as possible. Use a single movie light or an ordinary lamp with the shade taken off, and position it below the actor. This casts a soft glow, as well as a soft shadow, on the wall. While you'd normally try to avoid a shadow of this kind, in this shot, the character is opening a huge treasure chest. The shadow is a subconscious clue for the audience that she's looking down at something that's glowing.

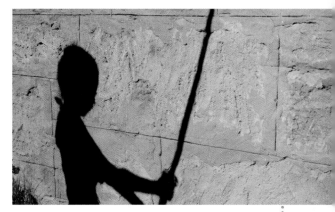

**3** Shadows can be more interesting than a direct shot of the action because they are slightly distorted. If you're trying to create a sense of fear or unease, a shadow can do the job for you. The first shot of the gun is quite disappointing, but the creeping, distorted shadow shows the audience what they need to know without showing them everything.

**4** A good shadow is also useful during action sequences. Here, a martial artist is training, and rather than show a standard training sequence, we see the actor's shadow. This is beautiful, and makes us want to see more.

**5** An extremely effective method for simulating powerful lighting is to park your car in sunlight (or indeed artificial light), outside an unlit room. With a little care you can direct the windshield light into the room. This creates a rich, bright glow which would take hours to create with electric lights. The first part of this shot captures the gentle motion of the leaves, and then the shadow moves in, and we can see that somebody is approaching.

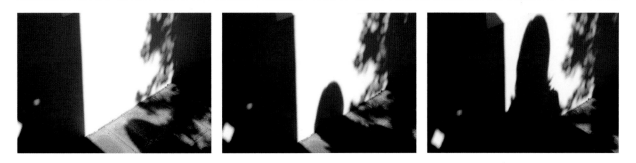

**6** Shadows look good when they move from floor to wall. The shadow appears to slide up the wall, creating a chilling mood.

# CAMERA ILLUSIONS

Pull-focus
Real Flare
Glare Fade
Multiple Directions
Split Focus
Twins
Window Illusions
Foreground Blur
Frame within a Frame

# Pull-focus

How can you show two great scenes without moving the camera? By shifting the focus from the foreground to the background. This is called pull-focus, and is one of the most popular effects in film and television. It can be used to create many different moods and transitions.

Pull-focus works best outdoors or in large spaces because you need lots of room between you and the foreground, and even more distance to the background. Shots that use pull-focus are a fantastic way to begin or end scenes. Although part of your image will be extremely out of focus, this only adds to the beauty of the shot.

**1** Switch off the automatic focus, and get used to focusing with the focus ring. Although you don't have to use a tripod, it's definitely a good idea if you are using long focal lengths. You'll need to zoom out your camera lens as far as possible, as though you are trying to bring distant objects closer. A normal lens will keep foreground and background in focus most of the time, but with a zoomed-out lens, you can only focus on one thing at a time. This is exactly what you want.

**2** Imagine you're about to show a scene inside a futuristic-looking building. You probably want to show an establishing shot of the building, but a straightforward shot would be boring. Instead, focus on the greenery, a fence, or something else of interest in the foreground. After a few seconds of shooting, manually change the focus to the background. The effect is simple, but effective. You'll find you need to be quite a way back from the foreground object—whether it's a tree, person, or object—for this to work.

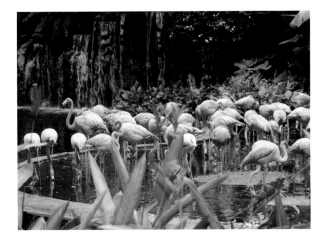

**3** Resist the temptation to show everything at once, because it weakens the impact of the location. The first image shows the entire flamingo park, with the waterfall and lake in view. A more effective introduction to the location is to start with a tiny, colorful detail. And good locations look even better when introduced gradually through pull-focus. Zoom in on a flower head, with the waterfall blurred out in the background. As you manually focus on the background, gradually lower or tilt the camera toward the flamingos. This gradual introduction to a breathtaking scene is more powerful than cutting straight to the main shot.

**4** Pull-focus is one of the best ways to direct attention to important details in your story. Imagine that your main character has lost an important letter. You don't want to show it falling out of a pocket—that's too obvious. You could cut to a shot of the letter on the steps, but a more tantalizing approach is to begin by focusing on the foreground leaves. As the focus changes to the background, the audience will want to see what's there, and the letter will be revealed. Directing attention in this way is an essential part of visual storytelling.

# Real Flare

When stray light strikes the lens of your camera directly, it creates a flare in the image. Lens flare can ruin a good shot, if it's unintentional. Used carefully, it can create a beautiful effect.

This is not a technique that you plan in advance, but one for which you can develop an instinct, and, over time, you'll learn when to use it to capture the moment. Although artificial lens flares can be added with software, nothing looks or moves like a real lens flare.

**1** You get different styles of lens flare with different lenses, and depending where you set the zoom. With a wide lens, the effect is a subtle glow, with a few blobs of light in the left-hand corner. This suggests that the sun is just off to the left. Lens flare works best when the sun isn't in direct view.

**2** Even when the sun is partially hidden by a cloud, you can achieve a good lens flare. In this shot, the bright flare helps to hide the location slightly. This is similar to adding smoke to a scene, or applying a misty filter. It creates a look that's just that little bit more intriguing.

**3** Reflections can also create lens flares, if they are bright enough. The reflection needs to come from a bright glass or metallic surface. Although your instinct may be to move the camera when you spot a lens flare like this, check to see whether or not it improves the shot.

**4** Some of the best lens flares can't really be planned. In this type of shot, you might not realize that the surfer is about to head in front of the bright sunlight. The point is, when you come to edit your footage, don't throw shots like this away. A bright lens flare can be a great moment to cut to the next shot.

**5** Imagine you want a shot of this field at sunset. The standard approach would be to shoot the shadows in the field, from above, but it's more interesting to embrace the lens flare and shoot toward the sun.

# Glare Fade

Directors are always looking for new ways to end one scene and begin another. Cross fades, empty frames, and establishing shots are among the many techniques used to achieve this. Here, the Glare Fade method is used to indicate a change of time and place between scenes.

The Glare Fade is useful for cutting to a flashback. When you shoot a flashback, the scenes from the past will probably be lit and costumed differently, but you still need to indicate that you're making an unusual cut to a completely different time and place.

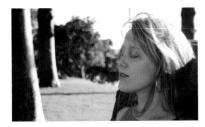

**1** The Glare Fade works best when you cut from a close-up of the character to a flashback scene. The actor here closes her eyes as the scene ends, as though she's remembering something. This is the first clue for the viewer that a flashback is on the way.

**2** The opening shot of the next scene should be a wide shot of a landscape. The transition doesn't work as well if the first shot of the flashback includes people in the frame, because they add too much detail to the image. This is more likely to confuse the transition between scenes.

**3** Load the clips into your software, and slice off a second from the end of the first clip and from the start of the second clip. Take these two mini-clips, and place them in the next layer up, as shown here. Apply the Brightness and Contrast filter, and adjust both clips until they are flared out to white.

**4** At the beginning of the first mini clip, set the opacity to zero, using the Pen tool, fading up to 100 percent. The second mini clip should start at 100 percent opacity, fading down to zero.

**5** Apply a Broadcast Correct filter to the sequence to ensure that the levels of color and brightness are acceptable on television screens. This is a good habit to get into, in case your images are ever broadcast.

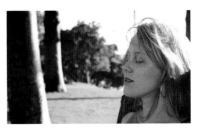

**6** When you're finished, the first clip should appear to flare to white, with the second scene emerging from the brightness. You can use the same technique to end the flashback and return to the present day.

# Multiple Directions

You probably won't even have noticed this, but master filmmakers use reflections all the time to help tell their story. When you first start making films, reflections are your enemy because you don't want the camera, the microphone, or the crew to appear in shot. But you can make reflections your ally.

A reflection lets you show two things at once. This means, for example, that you can see both characters' expressions, even if one character has his back to the camera. Sometimes this is more effective than cutting from one shot to the next. It does take more time to light and shoot for reflections, but it's worth the effort. Like so many good effects, the audience won't even know, consciously, that it's a technique, but it will enable you to tell your story more efficiently.

**1** Imagine that you want to show your character crying after an argument, sitting alone at a café table. You could open your scene showing exactly that, first from a wide shot, then from a close-up, but that's a little too ordinary. By taking advantage of a reflection, you can set up the scene with a close-up. The empty café table is reflected in the character's sunglasses, which she then removes to reveal her crying eyes. You can then cut to a wider shot and continue the scene.

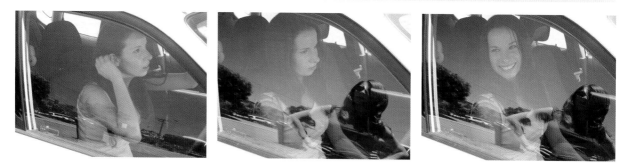

**2** This scene opens with the first character driving to a halt, and checking her make-up. While she's still unaware, the second character walks into view in reflection, and then they see each other. Not only does this look good, but it saves time, because trying to shoot the second character's arrival would otherwise involve several different angles.

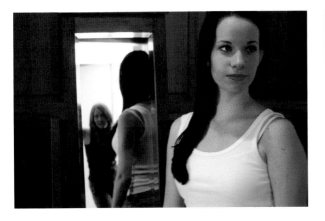

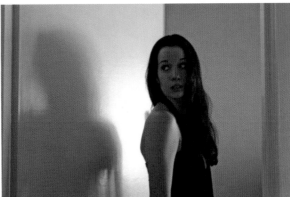

**3** Some directors hate mirrors, others love them. The beauty of a mirror is that it allows you to show two people in one space talking, without a cut. Some directors argue that this gives you less control over what the audience is looking at, so you might not want to use this all the time. However, it is often a good way to begin a scene.

**4** Reflections can be used to reveal something unexpected. Here, the character walks nervously through the house, suspicious that somebody is following her. This shot sets up the scene, revealing her tension, and also that she's going into the room.

**5** As she enters the room, the audience might be expecting a cut to reveal somebody else's presence. Or they may even expect an attacker to walk in front of the camera, following her. Instead, the door keeps drifting open to the left.

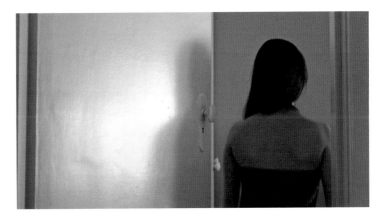

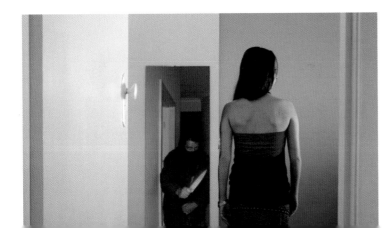

**6** The door is now fully open and the killer is revealed in the wall mirror, creeping up on her. Without a single cut, you've surprised and frightened the audience. Take care not to let your camera or crew appear in the shot.

# Split Focus

To keep the foreground and background in focus at the same time, you usually need to buy an expensive lens attachment, but this technique gives you a way to achieve the same result at no cost.

In a shot like this, you could pull focus between the foreground and background actors, depending on who's talking, or who you want the audience to concentrate on most. This is fine for a few seconds, but if this scene goes on, pulling focus backward and forward becomes annoying to watch. By blending two takes of the same scene, you can get both halves in focus at once.

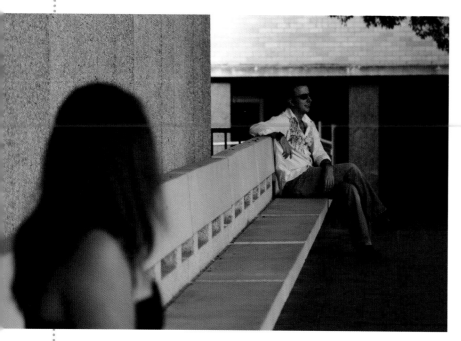

**2** Don't move the camera at all. In fact, it's better if you barely touch the controls. Instead, manually change the focus as gently as you can, so that the foreground actor is sharp. Now, repeat the scene exactly, but this time you are capturing the foreground performance. Time the scenes to make sure the actors are working at roughly the right pace. Don't pause between takes, because lighting conditions change quickly, which makes it difficult to blend takes.

**1** The shot is set up with both actors in the frame, but one is to the left and one is to the right. Split focus requires the use of a steady tripod and reliable actors, because you will need to capture the action several times at the same pace. First, get the background actor in focus, and record the scene.

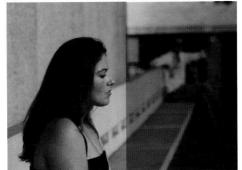

**3** This image shows that the frame is divided by the edge of the building. This is almost, but not quite, in the center of the frame, and marks a dividing line between the two halves of the composition. It is around this area that you will blend the frames together.

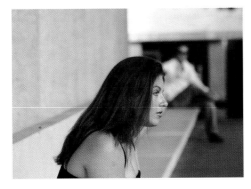

**4** It's vital that you never let either of your actors stray into this area where the frames will blend. The foreground actor's "leaning" motion would make it impossible to join the shots.

**5** With your editing software, put the sharp foreground on top of the sharp background in the timeline. Use the Crop feature (or similar, depending on your software), to remove the right-hand side of the foreground image. This reveals the sharp background and foreground at the same time.

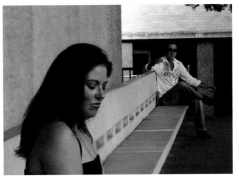

**6** Use a Feather or Soften setting to make the edge between the two layers more blurred. This will leave a blurred space between the two actors, but it shouldn't be apparent to the audience.

**7** You may need to slide the clips around in the timeline, to get the timing of the performances to match perfectly. The end result is a sharp foreground and background image.

# Twins

If you need to show a scene with twins, you can try to find identical actors who fit the bill. Unfortunately, this is rarely easy, so you may prefer to fake twins with a camera trick. This gives you much more latitude during casting and filming.

Actors relish the opportunity to play twins, because it gives them a chance to explore the subtleties of a character. The only drawback with these shots is that the camera must be stationary. If you shoot a whole movie about twins, make sure you add plenty of single shots of each twin, so that you can have some camera movement.

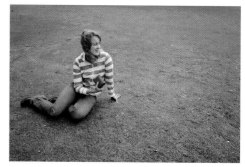

 Set up your camera on a tripod in a place where the background won't change. Here, the camera is angled downward at the actor, so that any background movement is out of frame. You could also have the actor sit against a plain background. Never attempt this with sky in the shot, as changes in cloud formation will show up when you link the shots.

**2** The next step is to shoot the entire scene for the actor on the left. Get an assistant to read out the lines for the second twin, so that your actor can get the timing right.

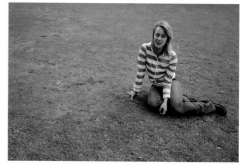

**3** As soon as you call "Cut" on the first twin, get your actor to move to the right-hand side of the frame. You must make sure that the twins don't overlap in the middle. If a costume change is required, be as quick as you can, so that the light doesn't change too much. Then shoot the scene again, with the same assistant reading the opposite lines, to achieve the same timing.

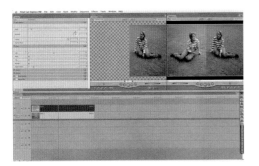

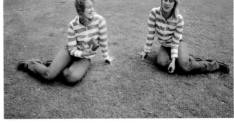

**4** Load the clips into your software, one on top of the other. Use the Crop function to remove half of the upper clip. This will make the clip below show through, effectively sewing the clips together. You may need to adjust the Feather or Softness controls to blend the clips more successfully.

**5** To achieve the finished shot, use the Color Correction tool to adjust any changes in lighting that may have occurred between shots.

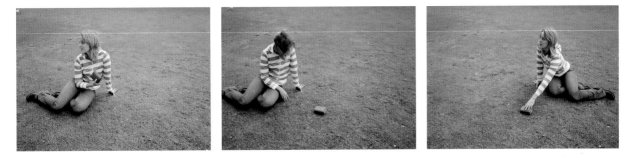

**6** You can even show one twin pass an object to the other twin. The first twin should take the object, and place it in the space between them. Then, when you shoot the second twin, she can take the object. Be careful not to place the object on the blend line as the Feather/Softness effect will show up.

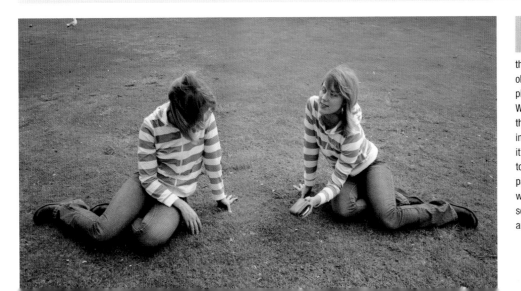

**7** When you join these shots, it will look as though one twin puts the object down and the other picks it up straight away. With practice you can get this to look almost instantaneous, as though it's being passed from one to the other without a pause. This not only helps with storytelling, but also sells the idea that there are two people in the shot.

43

# Window Illusions

Filmmakers sometimes need to create the impression that two disparate places are physically connected, even though, in actuality, they may be far apart. You can shoot an actor walking through a door, then cut to him walking into a room many miles away, and the audience will believe the two locations are in the same place.

The Window Illusion technique lets you show both locations at the same time, further enhancing the idea that the locations are physically connected. You create the impression that your character is looking out onto a street, even though she may not even be looking out of a window at all.

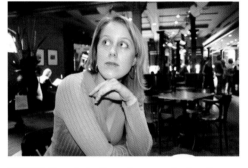

**2** The actual café may be many miles from the street and shot on a different day. In this setup, the actor is almost in the middle of the room. This enables the lamps to be set up correctly, and gives lots of room for the camera. The camera is locked off on a tripod.

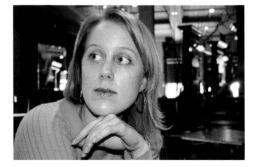

**1** An establishment shot of the street and the café helps to convince the audience that the following café scene is set in this street.

**3** For the shot itself, the actor pretends she's looking out of a window, when she is actually staring at the far wall. Use a long lens (zoomed in), so that the background is out of focus. The results are much better when you shoot this as a close-up.

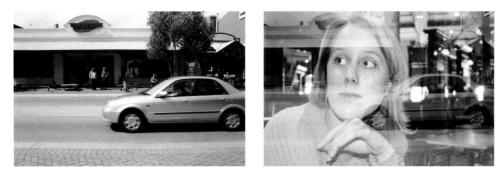

**4** Whenever you shoot your street scene, make sure you shoot with the same lens setting. Here, the lens was set to wide on the street scene, and as you can see, this doesn't quite match with the long-lens café scene. It looks as though two images are layered over each other. The audience won't know why it looks fake, but it will seem unrealistic and unconvincing.

**5** This shot of the street was taken with the same long lens setting as used in the café. Don't worry that it doesn't show the whole street; you are only trying to create the sense of the street being there. Shoot from approximately the same height as your character's head in the café scene.

**6** In your software, put the street scene on top of the café scene. Then change the Compositing Mode to Screen, and lower the opacity to about 70 percent.

**7** The finished shot works best when there's movement in the street scene, such as cars and people. To the audience it looks as though the character is sitting by a window, looking out at the street.

# Foreground Blur

Most of the time, you compose shots so that your actors can be seen clearly, with nothing in the foreground to obscure them. You can, however, let foreground objects drift into frame to create a depth of imagery rarely seen in short films. It also has a particularly voyeuristic effect.

This technique is frequently used in car advertisements, where a car may drive in front of blurred water droplets, or blurred grass and leaves. It's also used in feature films, and adds an extra touch of class to your images.

**1** Imagine you want to shoot a scene with your actor on this bridge, meeting another character. You'll want to focus in on your actor and avoid showing too much of the surrounding area. There are colorful flowers in the foreground, which you would normally avoid by shifting the camera forward..

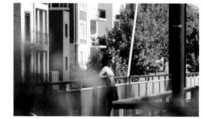

**2** The creative solution to this shot is to keep the camera exactly where it is and zoom out as far as you can. Now the actor is framed exactly as you want, and the flowers blur into a mass of foreground color. Without this foreground blurring, the image might be a bit stark.

**3** Sometimes, you'll get the best effect if your foreground object is brightly lit. The actor has been placed in the shadows beneath a tree, so the sunlit tree can be used for the blurring.

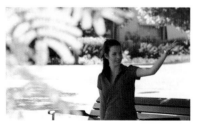

**4** Zoom out the lens and focus on the actor. Set the exposure so that the actor appears to be well lit. This makes the colorful leaves flare and blur, and makes a standard shot into something special.

**5** You can also use foreground blur in a shot with movement. Here, the actor is walking across the edge of a cemetery. The tree in the foreground can be used to create the blur.

**6** By zooming in on the subject, you achieve foreground blur with the tree. You also make the gravestones seem closer to the actor. And because the camera swings past the blurred foreground tree, the sense of movement is increased.

# Frame within a Frame

When you shoot a scene, you capture the scene and the characters in a rectangular frame. The rectangular shape of a cinema screen appeals to our sense of perception, and has been an artistic convention for centuries. This might be one reason why road movies are so popular, because the car windshield forms a frame within a frame.

Although the rectangular frame of the screen is beautiful, there are ways to make it more powerful. One is to exaggerate the look of the frame, and the other is to break it up. When you add another frame shape to the image, you create striking effects.

**1** The most basic version of a frame within a frame is to simply use another rectangular frame in the image. In this instance, the actor might have been filmed from the outside, looking in. Instead, we show her from the inside, so that the dark window exaggerates the frame.

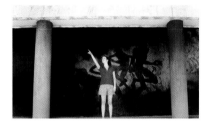

**2** If the frame itself is less obvious, you should arrange the camera so that it is perpendicular to the background. If this shot was taken at an angle to the wall, the frame-within-a-frame effect wouldn't show up.

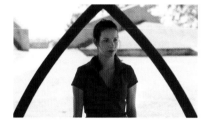

**3** You can also use objects to divide the frame. It's relatively rare to place your actor in the absolute center of the frame, but because she is reframed by the metal arcs, the image looks good.

**4** Sometimes, the frame within frame only needs to be suggested. In general, it's a good idea to divide your frame into thirds. You place your actor either on the left, in the middle, or on the right. Splitting a screen into thirds is a conventional way to divide the frame, whatever you're shooting. By using a suggested frame within a frame, you can strengthen the composition of the shot. Here, the pillar marks one-third of the screen. The center line of the bridge suggests another invisible dividing line, and helps to frame the actor. It takes time to develop an eye for this type of shot.

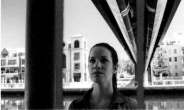

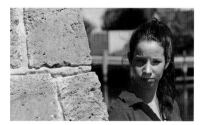

**5** Sometimes, you want to make the audience look at the actor's expression, but you may be saving a close-up for later in the scene. A creative response to this challenge is to use a wall or other object to block out part of the frame.

# CAMERA MOVEMENT

# Background Slide

To add a sense of movement to your shot, you can use a sideways camera movement to create the impression that the background is sliding across the screen. This is the sort of camera effect that the audience rarely actually notices, but which takes only a small amount of time to master, and greatly enriches a scene.

A scene with no camera moves can feel quite static and boring. By adding this sort of move, your scene will look more professional. If you find the effect difficult to visualize, this is one of the easiest moves to practice, inside or outside, so get out your camera and give it a try.

 **1** This sequence of shots shows the way you might normally show two characters meeting. You shoot one character with his back to the camera, and then he turns to greet his friend. We then cut to his point of view, and see the other character approaching. While this works, it's not very interesting visually.

**2** To create a background slide, the camera operator should move from right to left past the actor, while panning to keep him in the same position in the frame. The actors should stay in exactly the same place for this to work well. In this sequence, to add a little more motion to the shot, the character turns to face his approaching friend, but he doesn't move from where he is standing.

**3** When the camera move begins, the effect is subtle, especially if the character is stationary. The background moves slowly from right to left. Notice the position of the palm tree, and you can see the background sliding across.

**4** At this point in your sequence it helps to cut away and see what he's turning around to see. However, this reverse shot will also need some sense of camera movement, or the two will contrast too strongly. You could dolly toward the approaching actor, or pan with her as she walks up.

**5** The final result—as the camera move picks up speed—is a highly dynamic shot. As the actor turns, the background slides rapidly from right to left. As the move comes to an end, you should slow down the camera movement gradually. You could then take a couple of steps backward, as the other character walks into the shot, to show the two of them meeting. If you are uncertain about hand-holding the camera, use a dolly.

# Dolly Shot

One of the easiest and most seamless of shots in a Hollywood movie is one in which the camera follows the action as it proceeds. The dolly shot, as it is known, is used to close in on a person, to highlight a dramatic moment, or to physically move with an actor as he or she does.

The laborious and expensive way to achieve this shot is to use a set of tracks and a tray-on-wheels, known as a "dolly." These are cumbersome and take time to set up. Fortunately, you can achieve good results without a real dolly. Don't underestimate the power of these simple techniques. From time to time, the technique of employing a wheelbarrow or a wheelchair is used in Hollywood, because they are quicker and easier to use than a conventional dolly system.

**1** The first method is to use a wide lens, over a short distance, with a handheld camera. Start off close to the action, then move in even closer, holding the camera as level and steady as you can. You're not trying for a handheld look. Instead, aim for a smooth movement.

**2** This shot begins as the actor falls to the ground. When he looks up and around, the camera dollies in towards him. This allows you to show the action of the fall, and then show his expression, without a cut.

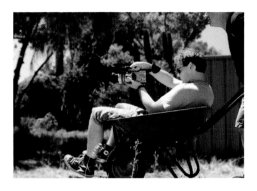

**3** For longer camera moves, you'll need to sit in something, such as a wheelchair or wheelbarrow. Never strap the camera to your wheelbarrow, because it will incur shake and make for a terrible shot. By sitting in the wheelbarrow, your grip cancels out any undesirable vibration, making the shot look ultra-smooth. You should deflate the tires slightly to help soften the movement. This sort of dolly can be used to close in on a character over a longer distance.

**4** You can also use a wheeled dolly to walk with a character, or two characters who are in dialog. Set up the shot so that you move alongside the actor, keeping the same distance throughout the shot. Start moving just before you call "Action," so the beginning of the move isn't visible.

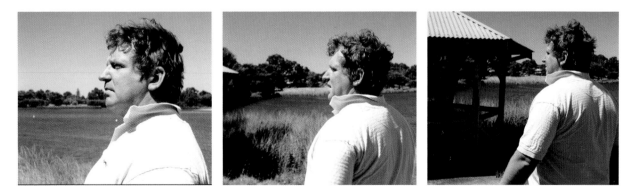

**5** Dolly moves can also be combined with a pan to increase the dynamism of the shot. Here, as the shot comes to an end, the actor walks away from the scene. The dolly slows, and we pan with the actor. Combined movements like this are more interesting than simple dolly moves.

# Fake Dolly

Dolly shots look good, but sometimes there's no room to move the camera. A quick solution is simply to zoom in on your subject, but this generally looks quite dated. Although a few directors still use zooms, most don't, because they think it draws attention to the camera, and makes the shot look more like something from a documentary or the news.

The solution is to combine a slight sideways movement with the zoom, which makes it feel as though the camera has dollied in. When you're short of room or working in a crowded space, this is an excellent way to get the shot you want.

**1** This is the sort of space where a dolly shot would be difficult. Although you want to move the camera straight ahead, there are chairs and tables in the way. Don't make the mistake of clearing the tables away just for the camera, because you take away half the atmosphere of the space. You can try to move chairs and tables while the camera moves forward (as Alfred Hitchcock was known to do), but this is usually more trouble than it's worth.

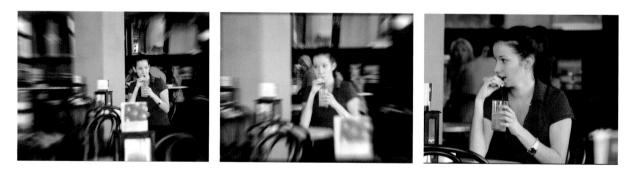

**2** The easiest way to deal with this is simply to zoom in on your character. Unfortunately, no matter how smoothly you do this, it looks too obviously like a zoom shot.

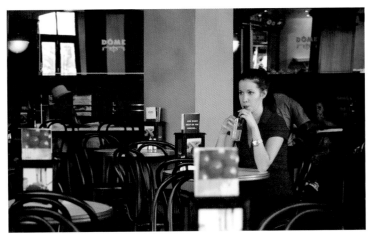

 **3** The Fake Dolly is achieved by moving your camera across the room, as shown by the arrow. You can simply take one or two steps to the side.

**4** The shot begins with the actor framed slightly to the right of the screen. Don't use the widest possible lens setting—in other words, don't zoom out all the way. You're trying to recreate a dolly move, not look as though the camera is flying across the room.

**5** As the camera moves to the left, you zoom in on the actor. Use the manual zoom ring, rather than the auto-zoom buttons. While less smooth, this creates an impression more like that of a dolly move.

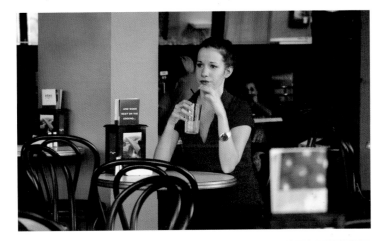

**6** Slowing down the camera move should coincide with the slowing down of your zoom. When the camera move comes to a halt, the actor can be framed more toward the left of frame. By combining this sideways movement with a zoom, you can create a remarkably realistic simulation of a straightforward dolly shot.

# Fall Away

A director is always looking for interesting ways to enhance an actor's performance. This is most important at dramatic moments, when a character learns something critical or reacts strongly to sudden news. The fall away combines lighting with camera movement to exaggerate a moment of discovery.

This technique is called a fall away because at the end of the shot the actor moves away from the camera, "falling" or disappearing into the darkness beyond. You may not use this exact setup, but it is a good template for any shot where you combine an actor's movement with a camera move and lighting.

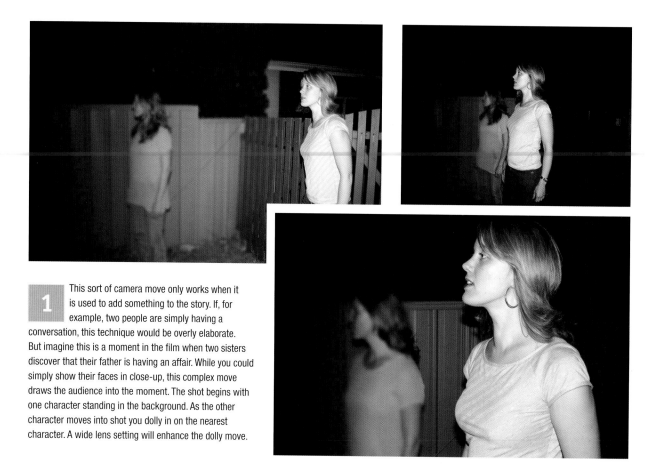

**1** This sort of camera move only works when it is used to add something to the story. If, for example, two people are simply having a conversation, this technique would be overly elaborate. But imagine this is a moment in the film when two sisters discover that their father is having an affair. While you could simply show their faces in close-up, this complex move draws the audience into the moment. The shot begins with one character standing in the background. As the other character moves into shot you dolly in on the nearest character. A wide lens setting will enhance the dolly move.

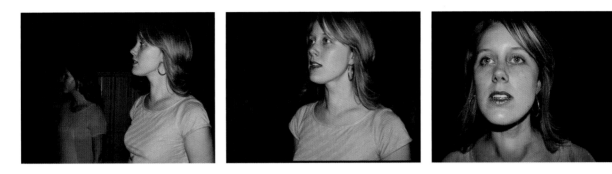

**2** As the shot continues, move around the main actor until she is framed almost centrally. Her eyes should not look straight into camera, but just over your shoulder. You can, at this point, cut to a POV (point of view) shot, showing what it is that she sees—but it might be better to save that for later. If you continue the shot without a cut, showing her fall away from the camera, you increase the suspense. The audience will want to see what she's looking at more than ever.

**3** This is the Fall Away move itself, where the actor backs off from the camera. She only moves a few steps, staggering backward as though in shock. Because you're using a wide lens, these two or three steps will make her seem to rush away from the camera. She appears to be enveloped by the darkness, which emphasizes the character's evident feelings of shock.

**4** If you set your lights up from the side, then the background won't be lit, and your actor can back off completely into the darkness. This is the ideal time to cut to the other sister, and then show her point of view, of the father being caught in a moment of infidelity, for example.

# Discovery Shot

A discovery shot begins with an image which will ultimately reveal your main subject. This switch technique is a great way to start a new scene. There's always a sense of surprise with a discovery shot; the audience is directed to focus on one aspect, but then the real action appears, and the camera changes focus to pursue it.

Following a tense scene at the evening dinner table, you cut to an empty park bench. This makes it clear that you've moved to a new time and place. Your characters walk in front of the park bench, and the camera follows them down the path. This is more effective than starting the scene with the characters.

**1** Imagine a scene where your main character has picked up her French horn, and told her father that she's going to find a new music teacher, before storming out of the house. You could cut straight to a scene of her walking through town, but that might feel too abrupt. Instead, start your scene with something that contrasts in an interesting way with the previous scene. Here, we show a sofa in an unusual place. This gets the audience interested— why are we looking at the sofa? The audience may expect somebody to walk into the shot and interact with the sofa. In fact, it's just a way to open the shot. The main character walks into shot, and the sofa is replaced by her French horn. We immediately know that she's gone from her home to somewhere more unusual, and follow her into a wide shot of the location. This works more effectively than a cut, and is more interesting for the audience.

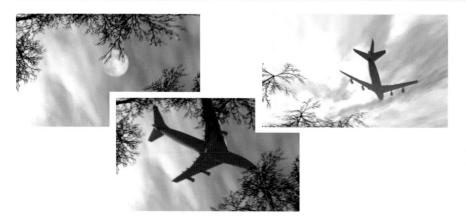

**2** In this shot, the audience is led to believe that it's just another "full-moon" shot, as depicted in thousands of movies. But then the airplane moves into shot, and the camera follows. It's a powerful image, but be wary of using techniques like this just because they look good. This shot would only be worthwhile if the audience is waiting for a character to arrive by air.

# Walk-in

In high-quality film and television, you rarely see the director cut from one dialog scene straight to another. There's usually a camera move at the beginning of the new scene, which acts as a pause for breath. This may only take a second or two, but it is much more effective than cutting straight into the scene.

The Walk-in is one of the most frequently used tricks, and it remains a reliable method for creating visual interest at the start of a scene. The scene opens and we're introduced to a character, but then another character walks into shot, and the camera follows.

**1** When the scene begins, you focus on one character, some distance away. This doesn't have to be a major character in your film, although that does help to catch the viewers' interest.

**2** Ideally, this character should be doing something other than simply walking, something that makes the audience ask a question. Here, the audience will ask themselves, "What's so important about this book that he has to read it while he's walking?" This is a moment of misdirection. The audience will think the scene is about this character.

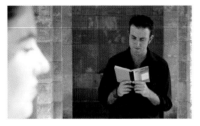

**3** A moment after setting the scene with the first character, another actor should walk in from the side. This is the actor who is going to play the rest of the scene. She should be quite close to the camera, so that she almost fills the frame. This will, of course, mean that she is out of focus when she first moves into frame.

**4** Use the manual focus ring to change the focus as she moves toward the center of the frame.

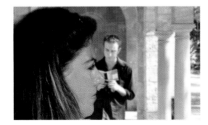

**5** Keep the camera still as you focus, until the actor has almost completely filled the frame. Then you can begin to follow her with the camera.

**6** You're creating the impression that something has caught your eye, and that your attention has been dragged away. Keep following the second actor until the first actor is no longer in sight.

# Camera Flow

Sometimes, there's so much to show in a scene that to keep cutting from character to character would be too jarring. The solution is to let the camera flow with the action.

If you're shooting a scene in which the characters move around a lot as they talk, the camera flow works well. Sometimes, you may use camera flow for the first 30 seconds of a scene, then when the actors settle into place, you can go back to the more familiar cutting technique.

 **1** Start the shot with an empty frame. Although you may cut this out when you edit, it's always a good idea to start this way. It's easier to cut an empty frame out than it is to add one in later.

**2** The first character walks in. In this shot he's making a comment to a character who's walking in from the opposite direction. As she enters frame, she responds by laughing, which catches our attention.

**3** When she hits the center of the frame, we follow her. It's possible that he will continue talking as he moves off screen, but we follow her now.

**4** As she walks, a third character comes into view, sitting on a bench. Although you could simply have the walking actor come to a halt, and keep the seated actor on screen left, this would interrupt the flow. Instead, keep following the walking actor, until the seated actor is screen right.

**5** Rather than cutting to each character as they talk, we watch the seated character for a moment, until the walking character returns. You need to give the characters a reason to be moving around so much. Here, they're preparing for a party.

**6** The walking character moves back across the frame. Let the camera follow her, but this time stop when the seated character is left of frame. Both will now be ideally placed for the rest of the scene to be played out with a normal cutting technique. Or you can keep the flow going by getting the seated character to stand up and move, or having the first character return. It takes practice to get these flowing moves right, and recording sound can be a challenge, but the end result is worth the effort.

# The Spin

How do you light and set up a scene so that you can spin around the characters as they interact? This much-loved effect can be a challenge to shoot. After all, where do you hide the lights? It can take a while to set up, but once you're shooting, you get lots of footage in a short space of time.

The spin is a great way to keep a scene with lots of dialog interesting. The main challenge is to get a perfect take, with no mistakes or poor lines, because the shot cannot be edited. Thankfully, actors enjoy rising to this sort of challenge.

**1** The camera circles around the actors as they talk. Sometimes both are completely in the frame, and at other times you focus on one more than the other. Keep moving in one direction until the scene has finished.

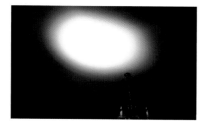

**2** Lighting this kind of scene is tricky, because any lighting stand will be visible in the shot. One solution is to put the light down very low on the floor, between the actors, and point it up at the ceiling. The bounced light illuminates the actors' faces.

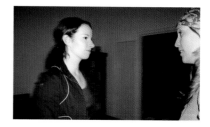

**3** As you begin the move, think about framing. If you simply point the camera at the space between the actors, the result will be uninteresting. Instead, as you move, let the camera shift attention from character to character.

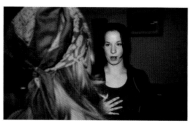

**4** Every few seconds you will pass behind the head of one actor, and you should get past as quickly as possible. However, the next instant is the most interesting part of the shot, because you're looking straight into the other character's eyes, so slow down.

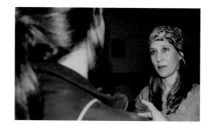

**5** No matter how carefully you time your move, sometimes your camera will be pointing at the actor who isn't talking. This is fine, as long as you direct your actors to really listen to each other. If they listen to each other's lines, the result will look convincing.

**6** The Spin can work just as well from a low angle, depending on the effect you're trying to create. You can even make the transition from a high to a low angle as you move.

# Reverse Spin

A great technique to emphasize a moment of surprise is called the reverse spin. To create it, you spin the camera in a direction opposite to the actor's movement, to reveal a surprising element in the background. You can also use the reverse spin to reveal locations, or shocking events such as explosions, but it's particularly effective when used to reveal people.

The camera move itself is quite simple—all you are doing is moving from one straightforward shot of the actor to an over-the-shoulder shot from the other direction. What makes the shot is the contrast between the actor's movements and those of the camera.

**1** Begin the shot with the camera looking at the back of the actor's head. Keep the camera quite close. The other actor, out of sight of the camera, can already be in position.

**2** Time the camera move so that when it reaches the halfway point the actor has turned around completely. This allows us to see her reaction, before we see what she's seen. Keep your hand on the focus ring, ready to focus on the second character.

**3** Settle the camera into an over-the-shoulder shot to reveal the second actor, adjusting the focus to make him the sharpest part of the image. The whole move should take only a couple of seconds, with the camera moving as fast as she does.

**4** It helps if there's a sound to motivate the jerk of the head. Here, the character hears a noise behind her and spins around to see who is there. She recognizes the man, and reacts accordingly.

**5** In this scene, the character has returned to confront an ex-lover. The reverse spin shows her reaction and his return in one shot, without cutting away or setting up multiple camera angles. It's also useful for moments of real horror.

# Hand Crane

One of Hollywood's most beloved techniques is the crane. This is a camera movement whereby the camera glides up and down through the air, remaining level as it does so. A simple technique enables you to duplicate this without the need for extra equipment.

While the Hand Crane is a handheld move, you should try to make it as wobble-free as possible. It may take some practice, but it will make this move look as though it is being performed with a mechanical crane.

**1** On Hollywood sets or in TV studios, the camera is moved on a large platform or crane. The movement is fairly slow and extremely smooth. During most crane shots, you don't tilt the camera at all, but keep it level with the ground. This enhances the feeling of upward or downward movement.

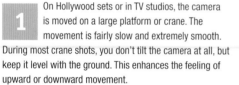

**2** Crane shots are an excellent way to begin a scene. In this shot, we start on the actor's feet as the door closes, showing that he has just stepped out of the car. Then we move up his body, see him pocket the keys, and finally we rise up to his face. This is far more interesting than simply pointing the camera at him from a distance as he gets out of the car. The danger with a shot like this is that, part way through, you may be showing nothing except the actor's hips. This is why the actor was directed to pocket the keys. Always make sure there is some action in the shot, however incidental.

**3** To achieve the Hand Crane shot, hold the camera loosely in your hand from above, and adjust your grip until it feels well balanced. When you've found a grip that keeps it level, you can begin shooting.

**4** As you raise your arm, tilt your wrist so that the camera remains exactly level. You must practice this before the day of the shoot, because it takes a while to get exactly right.

**5** As well as raising your arm, you will also need to swing your arm around to follow the actor as he walks away from the car. Don't pan by turning your wrist, but by moving your entire arm in line with the actor. Imagine that your arm is the arm of the mechanical crane and you should be able to get the movement right.

**6** Throughout the shot, use the viewfinder to determine whether the shot is working. Don't look at the camera itself unless you have to, because it's easier to judge how level it is by looking at the image being produced.

# Motionless Camera

Although camera moves add interest to a scene, it's unlikely you'll be able to keep the camera moving all the time. It takes too much planning, and lots of effort to get the camera moves right.

When the camera stays still, there are several ways to keep the shot interesting. By using exaggerated character movement and careful positioning, the still frame can be just as dynamic as a camera move.

**2** You can keep the shot rolling until she eventually rushes past the camera, which would give you a good point to cut. If you plan to do this, position your actor close to the camera when you set up to make sure she will be accurately framed as she passes by, then send her off into the distance to begin the shot. Manually change the focus as she approaches, to keep her sharp.

**1** The camera is placed at a distance from the actor, and zoomed in fully. The actor has been directed to follow the curve of the path, rather than run directly toward the camera. This means that she moves across the frame as she gets closer. This sort of lateral movement helps to keep the shot interesting. This shot will last for about 30 seconds, and could be used as the opening shot of a movie.

**3** When the camera remains still, your actors should move. Here, the actor moves across the screen and toward the camera. A short lens is used to make her approach seem more rapid. In just a few steps her image expands to fill the screen. Although she appears to be a couple of feet from the camera at the end, her face is only a few inches from the lens. Get your actor to stand in the final position when you set up the shot, then move her back to the starting point.

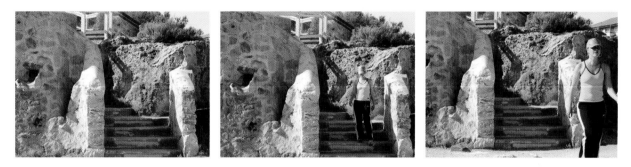

**4** Lateral movement across the screen keeps this shot interesting, but it is also enhanced by moving the actor down the screen. This sequence could have been shot on a level pathway, but the stairs add a vertical movement which makes it more compelling. Notice that her shadow appears in view before she does, which is a subtle touch that attracts the audience's interest—it makes them wonder what's coming next.

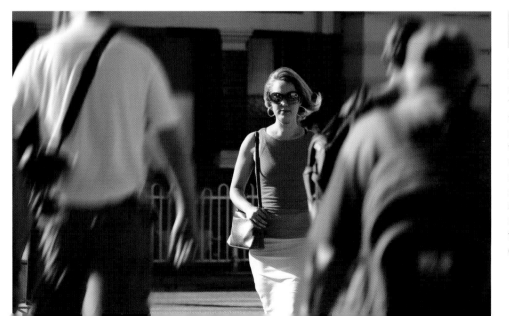

**5** The actor walks slowly toward the camera, but extras have been positioned in the foreground, walking away from the camera. They are out of focus, and their movements seem more emphatic because they are closer to the camera. The audience remains focused on your main character, but the surrounding movement makes this feel more real than if she was filmed on her own.

# Handing Off

Handing off is a technique that is used to maintain a sense of dynamism in a shot without too much distracting movement. For example, if you move your actor and your camera too much through a scene, the result can look confused. With this technique, the actor and the camera take turns to move.

By sharing the movement—or "handing off" the motion—you keep the shot fluid. This example is a simple version of the technique, but it can also be used for extremely long and complicated scenes.

 When an actor moves through the scene, the temptation is to set the camera down in one place and pan to follow the action. In this shot, the actor walks to the middle of the set, stops to look around, then walks off. Although the pan works reasonably well, it's a little static. It comes to a complete stop when the actor is motionless, which is too abrupt.

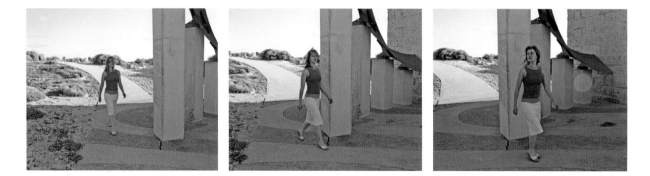

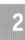 To achieve the handing off effect, begin from much farther back, panning with the actor as she moves. As you are quite a distance away this pan will be ever so slight and won't feel like a full camera move. Slow the pan down as she comes to the center of the set.

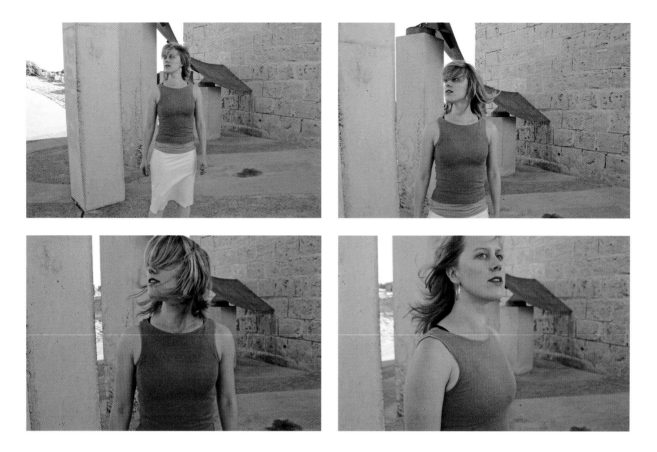

**3** As she slows to a stop, you should begin your dolly move forward. You can even do this handheld, walking gently toward the actor. Time your move so that you slow to a halt just as she is about to move off again.

**4** As soon as she moves away, you should remain stationary, but follow her with a pan as she leaves. This sharing of motion gives the scene a subtle sense of movement, but also lets you focus on the dramatic moment when she looks around as though she is lost. With the forward motion, the audience senses that this is something they are supposed to notice and they will scrutinize her expression closely. If you were to simply pan with her, the moment would not seem anywhere near as significant.

# Criss-cross

You've often seen this one—where a character is required to storm up and down corridors, talking as they do so. There are many ways to shoot this scene, walking with the characters, zooming in on them from a distance, or even following from behind. The criss-cross maneuver, however, is ideal for creating a sense of urgency.

Imagine you're shooting a scene where two characters rush past as they talk. Rather than simply panning with them, rush toward them with the camera to double their apparent speed.

**2** In addition to panning, move toward the actors as they move toward you. This can be achieved with a handheld camera. Set your lens to a wide angle to further exaggerate their movement.

**1** The standard way to shoot people walking past is to pan. That is, the camera stays exactly where it is, but pans from side to side to follow them. Although you will use the pan in this camera move, it's only part of the effect.

**3** The scene can begin with the actors in the center of the screen. If you're shooting handheld, you can also stand in the middle of the corridor.

**4** As the actors get close, you should take several steps toward them, and begin to pan so that they are framed on the right of the screen. This leaves an empty space on the left of the frame for them to walk into. By leaving the empty space on the left of the frame at this point, you increase the sense of movement when they actually fill the frame.

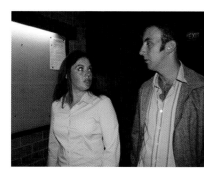

**5** As the actors come close, slow down your forward motion, concentrating instead on panning with the actors as they walk past. If you pan and keep rushing forward, there will be too much motion blur to see their faces clearly.

**6** As the shot ends, you should keep walking backward and panning with them. If you want to keep the momentum of the scene going, walk backward, away from them. You should always have somebody with you to guide you safely—preferably standing behind you, holding on to your shoulders. This can be tricky in a confined corridor, but it's better than walking into a wall.

# EDITING ILLUSIONS

# Wall Cut

How do you end one scene and begin another? By dollying the camera across the room, you can use the door frame or wall to slide the next scene into view. Rather than just cutting from one scene to the next, you use the sliding wall to drag in the new image.

Usually, cuts are meant to be invisible to the audience, so use this technique when you really want the audience to know that there's a scene change. This is particularly useful for flashbacks, and is used all the time in TV series such as *Highlander* to cut between the present day and a scene from the past.

**1** Find two locations that don't match up at all. If you were cutting between the bathroom scene and a bedroom scene where somebody else is getting ready, this technique wouldn't work; it would look as though the camera was simply moving from room to room. It works best when the images are radically different. The wall or door frame only needs to appear in the first shot for this to work, but the camera should be moving in the same direction and at the same speed in both shots.

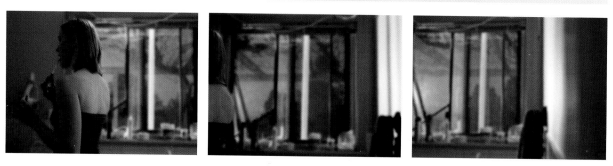

**2** Set up your first shot, and let the scene play out. When the scene is about to end, you can begin to move the camera across the action. Whether you use the homemade dolly or a handheld camera, keep the movement progressive and smooth. Don't pan the camera to watch the actor, and don't "look" for the wall. Keep the camera pointing straight ahead as you move to the right past the door frame.

**3** When the wall or door frame comes into view, don't stop—keep moving until the next room is completely in view. Although this room won't show up in the finished shot, it's important to maintain the same sideways pace until the door frame is completely to the left of screen.

**4** Shoot your second shot—in this case, by the ocean—dollying to the right as the scene opens. Make sure the pace of the second shot matches the first. Load both shots into your editing software. Put the first shot on top of the second shot. They should overlap by a couple of seconds.

**5** Select the first clip, and go to the Motion settings. When you drag the Crop Right setting slider, you will see the first image disappear, revealing the second image. Set the Crop tool so that it aligns exactly with the edge of the door frame, and click the Keyframe button. Then go to the point where the door frame is at the far left of the screen and drag the Crop Right slider until the ocean image is completely revealed.

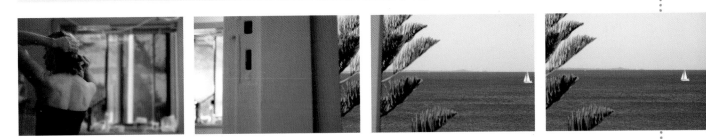

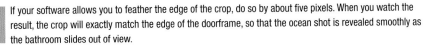

**6** If your software allows you to feather the edge of the crop, do so by about five pixels. When you watch the result, the crop will exactly match the edge of the doorframe, so that the ocean shot is revealed smoothly as the bathroom slides out of view.

# Passing Through a Wall

This is an effect often used in the movies. The camera appears to move straight toward a wall and then pass through it, as a ghost might do. This effect requires some familiarity with your computer software, but it isn't very difficult to do.

The trick is to keep your camera movements smooth and flowing, so everything blends together. You can, of course, shoot the outside wall in a completely different location to the interior room. As long as the illusion looks real, it doesn't matter where or when the different shots actually occur.

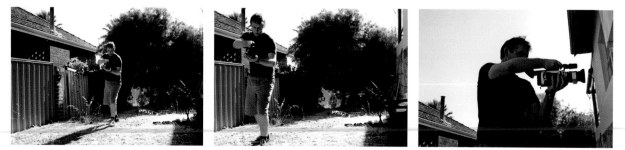

 Your aim is to create a swooping motion toward the wall. If you head straight for the wall, the audience won't see anything except a wall filling the frame, and as such, won't know where the shot is supposed to be happening. By moving alongside the wall and then turning toward it, your shot will be more effective.

 The resulting shot shows the camera moving down the alleyway, and then turning suddenly toward the wall. To the audience, it seems as though the camera is about to smash into the wall. Keep your lens wide to exaggerate the wall rushing up, but be careful not to actually walk into the wall.

**3** Shoot footage of walls (as shown, left), both indoors and out. For each segment of wall, shoot five or six seconds so that you can easily load the clips into your software. These clips will be blended to create the sensation of moving through a brick wall.

**4** In your editing software, arrange the clips so that as the opening shot comes to a close, one of your inner-wall shots fades up. Use the Opacity controls so that each wall clip fades rapidly to the next.

**5** To create the sensation of moving forward, you should also make the wall clips grow larger while they are visible. When the first wall clip begins, it will have a Scale of 100 percent. Click the Keyframe button, then go to the end of the clip, and set the Scale to 130 percent. Repeat this for the other inner wall clips. Experiment to see how much scale change is required to create an illusion of motion to match your footage.

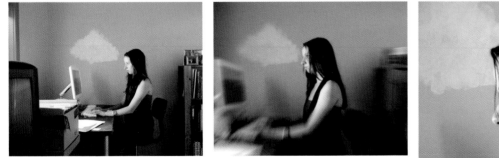

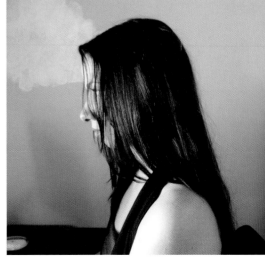

**6** Finally, you should fade through to the interior scene. This should be shot with the same forward speed as your exterior shot, to complete the illusion. Once you've apparently moved into the room, you can slow the forward motion down again, coming to a complete halt. Or you can continue to pass through wall after wall, swooping through the whole house, depending on your desired effect.

# Whip Cut

The whip cut is a clever way of joining shots together without the audience realizing there's been a cut. This means you can shoot one actor in one location, then shoot another actor in a different location, and make it look as though they are in the same place.

In this example, there were two ideal locations to shoot the actors: the bench and the hedgerow. Unfortunately, they were more than five minutes away from each other. The whip cut allows us to create the illusion that everything is happening in one place.

**1** There should be some motivation for the camera move. When the actor hears his friend approach, he looks up. Begin your camera movement as he moves his head. Try to create the illusion that his look is "throwing" the camera's gaze to the left.

**2** The rapid movement to the left creates a strong blur, which is essential for the effect to work.

**3** Keep the camera move going, quite rapidly, until you've turned 180 degrees. You probably won't need all of this footage, but it's always a good idea to have more footage than you think you'll need.

**4** In the second location, repeat this procedure in reverse. Start with a fast camera move, from right to left. This means the shot opens with the blur.

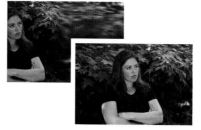

**5** The camera should come to rest on the second actor. They can now begin their dialog. Both actors should be present in each location, so that they can feed lines to each other.

**6** To make the Whip Cut work, load the clips into your software, and apply a basic cross-dissolve between the two clips. You may find that a quarter of a second of blur between the two actors is sufficient.

# Flash Cut

Essential in music videos and common in flashbacks and dream sequences, the flash cut flickers many images across the screen over a period of a second or two. The effect passes quickly, but creates a visually intense moment. It works best when you have a lot of good images to use.

The flash cut was almost impossible until the advent of digital technology, because it allows single frames of footage to flicker past each other. With film, it was impossible to splice together single frames. Now, using DV cameras, the effect is easy to achieve.

**1** Here, a music video set around the coastal parklands makes use of shots from many different angles. If this was a film about life on the streets, you wouldn't use these images for a flash cut, no matter how good they look. Shoot material that's appropriate for your project.

**2** Load the clips into your software, one above the other. By layering them in this way, you can cut "holes" in layers to reveal the clip that's lower down. By doing this repeatedly you can create many cuts per second.

**3** You'll notice that the clips are all different lengths. Although you can edit them to the same length by cutting them, you can also use the Speed feature to speed some clips up, until they are the same length as the rest. This can increase the flash cut effect by creating extra frame blending.

**4** One way to create the flash cut is to apply a Blink filter to each layer, with slightly different On and Off durations for each layer.

**5** If you don't have a Blink filter, you can delete bits from the various layers, so that as time passes different layers are revealed. Don't cut the lowest layer in your timeline, as this is the layer that shows through when all the others have been cut away.

**6** If you place a rush of images between two fast-moving action scenes, you can end up with too much movement. The flash cut works most effectively when they join two relatively placid scenes. Here, the slow-moving swing precedes the rush of flash-cut images, and is followed by the seagulls.

# Slow Motion

When directors want to show slow motion, they double the speed of the film going through the camera. Played back at normal speed, this creates slow motion. It's impossible to slow down DV tape, but lots of people want to create the slow-motion effect.

It's easy to achieve slow motion with your editing software, but ordinary footage slowed down flickers excessively and looks blurred. To get smooth-looking results that are as fluid as film, you need to capture the images with a faster shutter speed.

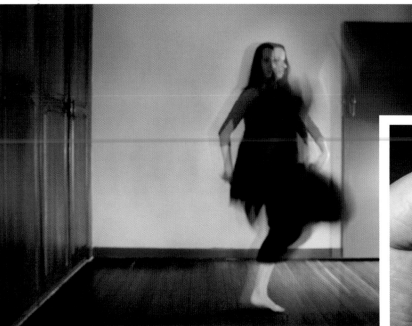

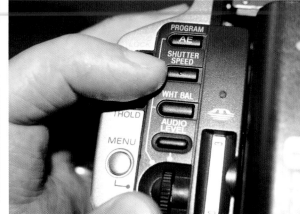

**1** Slow motion is most effective when you slow down action that's fast to begin with. You can slow down a shot of somebody turning their head, but this looks less impressive than a rapid dance or fight sequence that's been slowed down. By adjusting the speed of the footage in your editing software, you get instant results. Unfortunately, each frame will be a rough blend of one or more blurred frames, which creates poor results.

**2** The secret to achieving good slow motion is to use a fast shutter speed. You still capture the same number of frames per second, but the shutter only lets light in for a tiny fraction of time. Use the manual controls on your camera to adjust the shutter speed.

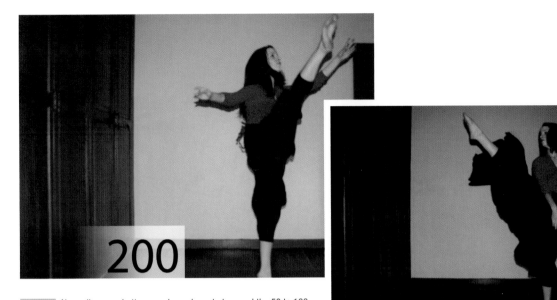

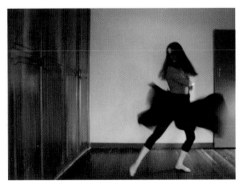

3 Normally, your shutter speed may be set at around the 50 to 100 mark. This means that the shutter is open for less than 1/100th of a second for each frame that's recorded. Fast-moving objects will still blur with a shutter speed of 100, and that's exactly what you want most of the time because motion blur looks realistic. However, for the best slow-motion footage, you want each frame to be relatively blur-free, so set the shutter speed as high as you can.

4 You may find that a high shutter speed causes the image to darken considerably. If you need to, add more light or bring the shutter speed down slightly. Make sure that each frame looks like a still photograph, with no blurring.

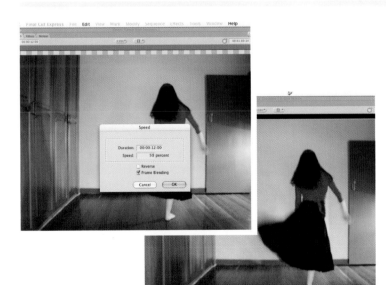

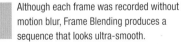

6 Although each frame was recorded without motion blur, Frame Blending produces a sequence that looks ultra-smooth.

5 Load the footage into your software and reduce the speed to 75 percent or 50 percent, depending on how slow you want the footage to appear. Check the Frame Blending box.

# Supernatural Speed

Whether you're shooting a fight scene or a moment when something shocking happens in a horror movie, you often want the action to happen faster than it does in the real world. Most software allows you to speed up your footage, but this often doesn't look terribly convincing.

The solution is to shoot the scene as usual, then use your editing software to remove some frames of video when the main action occurs. In this example, the actor is wearing horror contact lenses, and turns her head to camera at supernatural speed to frighten the audience. This super-fast head turn is a vital technique in modern horror movies. The technique can also be applied to fist fights, sword fights, and action of any kind to make the hero look faster than human.

 Snap movement creates the most surprise when it follows a moment of stillness. To get a moment of stillness, you must first have some movement. Begin your shot with a simple camera move. In this case, we close in on the actor slowly, and then the camera comes to rest.

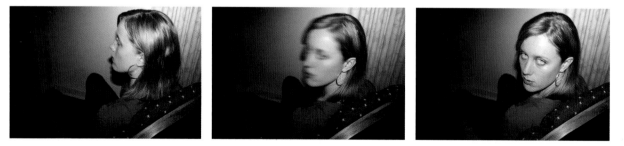

**2** As soon as the camera comes to rest, the actress should turn her head. Although the software will be used to increase speed, you get more realistic muscle and hair movements when the actor moves as quickly as possible.

**3** Load the shot into your editing software. You can use the Blade tool to make two cuts to remove a short sequence of frames. The key is to take frames from the middle of the action, leaving the beginning and the end of the actor's movement. If you cut out the beginning or end movement, the result looks comical. Only remove action from the middle of the actor's movement.

**4** The camera must be stationary for this shot to work. If there is camera movement, it will be exaggerated when frames are removed, and the final shot will look like a strange cut, rather than a shocking moment. When you have removed the frames, close up the two halves of the clip and watch to see how well it works. Adjust the edit until you get the required result.

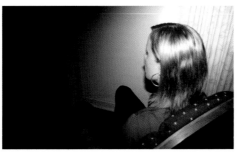

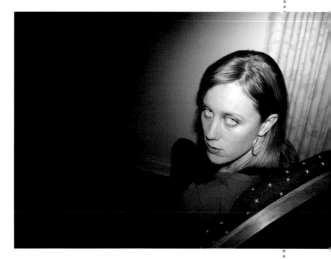

**5** Sometimes the overall motion looks good, but there is no motion blur. When objects move quickly, they blur in the camera. To add blur, make a copy of your clip, and place one above the other in your editing software. Apply a mask to the upper clip (with the 8-point Mask filter) and arrange the mask points around the actor's face. Now apply a Blur filter. The actor's face will be blurred, but the rest of the image will appear sharp. Shorten the blurred layer on either side, so that the blurred image only appears at the time of head movement.

**6** The result is dramatic. The camera moves in, comes to rest, and then the actor's head turns in a fraction of a second.

# Off-camera Action

With off-camera action, you can imply that something has happened without actually seeing it happen. This might be a fight, a break-in, or a gunshot. Instead of showing the action, you show the result of the action.

One reason to use off-camera action is that it saves you having to shoot another complex scene. When used sparingly, it's also an excellent way to tell the story, because it creates a moment of tension that is resolved in an unusual and visually interesting way.

**1** Off-camera action is most effective when you use a continuous shot, without any cuts. A cut breaks the tension of the scene and disconnects the action from the character, so keep the camera rolling throughout. The opening of your shot should establish exactly what's at stake. In this example, the character is clearly looking for somebody dangerous, perhaps aware that he is being stalked. Whatever objects you use to show the off-camera action should be visible in this shot. Here, the actor walks behind the box that is about to fall. This makes the audience look at the box.

**2** Your assistant should be positioned behind the boxes, ready to push one off when the actor disappears from the frame. During the editing stage, you can add a "punching" sound a moment before the box falls.

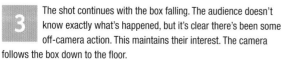

**3** The shot continues with the box falling. The audience doesn't know exactly what's happened, but it's clear there's been some off-camera action. This maintains their interest. The camera follows the box down to the floor.

**4** A moment later the gun slides into view, and the story is revealed. We now know that the hero was knocked over and disarmed. Notice how the box was used to lead the camera down. If we had simply shaken the box, then tilted down to the floor to see the gun slide in, the shot would feel contrived.

# Photograph Freeze

When you need to show that somebody is under surveillance–for example, in a thriller–you can use this trick. This technique gives the audience the point of view of the character looking through the camera viewfinder, and each time a picture is taken, the image freezes into black and white.

Although this technique has been around for a long time, it is still quite effective.

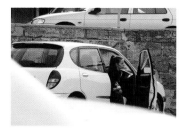   

 **1** Shoot your actor's full sequence from a distance, with the lens zoomed out. You can use a tripod to steady this shot, but loosen the tripod a little, so that you can inject some gentle shake into the image. You want it to appear as though a photographer is tracking the character while looking through a handheld camera.

**2** Load the footage into your software, and check through the clip to see which images will work best as stills. The strongest moments are those when something happens—a head turn, checking a watch, a slamming door.

**3** To create the photograph, make a cut in your footage, and separate the two halves of the clip by a second. Go to the end of the first half of the clip, and choose Make Still Frame (or similar, according to your software). This will create a long, still image from the last frame. Apply a Desaturate filter to the frozen clip to make it black and white.

**4** Drag the frozen clip to the timeline. A brief freeze may be all that's required, but if you want the audience to notice particular details in the black-and-white image, you can leave it on screen for over a second. Add camera shutter sound effects. The printed stills in the hands of the photographer is a good opening shot for the next scene.

# PRODUCTION EFFECTS

# Moving Lights

Another common effect is to fake an elevator scene using moving lights. This effect is subtle, but very convincing. Alternatively you can use bright, exaggerated lights to make it look like the elevator is part of a futuristic sci-fi setting. We've all seen this effect used in *Star Trek*, for example.

In this example, the actor is shot against a blank wall, and the moving light is added to create a science-fiction effect. To the audience, this won't look like a special effect. They will think they are watching somebody ride in an elevator.

**1** Shoot your actor against a blank wall, with the camera on a tripod. This will enable you to accurately match the moving light footage to the shot. Light from above, angled so that it fades off into darkness. This provides contrast for the patches of light.

**2** Film a variety of stationary light sources, such as your movie light, a household lamp, smoke lit too brightly, and smoke lit accurately. It's good practice to shoot several different sources, so that you have more to choose from.

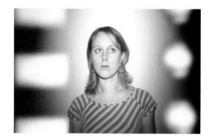

**3** Load the clips into your software, with your chosen light footage on top in the timeline, and set the Composite Mode to Add. Change the scale to about 20 percent, and use the Crop tool to leave a rectangle of light in the frame.

**4** Position the rectangle below the screen, then click the Keyframe button. Go to the end of your clip and drag the rectangle above the top of the frame.

**5** Duplicate the light clip, change the scale to about 25 percent, and apply a Gaussian Blur filter. This adds a mist of blurred light around the main rectangle.

**6** Copy your light clips and offset them in the timeline. They will appear one after the other, like a stream of light rising up the wall. Apply Color Correction.

# Flickering Overheads

Flickering lights can be very effective in any number of scenes, but are often put to good use in the horror genre. They can indicate an imminent power failure or create a sense of unease. Getting lights to flicker convincingly on set is difficult, but you can create the same result with your software.

You will need a fluorescent light on set. This won't be used for lighting the set or the actor, but will be filmed directly to show the actor's point of view of the light. As always, the end result can be greatly improved by adding suitable sound effects.

**1** Your shot should begin with the lights apparently functioning well. After a few seconds you can begin the flickering. Your actor will, of course, have to imagine that the lights are flickering.

**2** When the flickering begins, your actor should look up in the direction of the light. In reality, there probably won't be a light there at all. Mark a point on the wall for your actor to look at.

**3** Film a shot of a fluorescent light, from your actor's point of view. When you switch the fluorescent lamp on, it will flicker as it warms up. When cut into your sequence, this will give the right impression.

**4** Rather than cutting back to the same wide shot of your actor, shoot a close-up from a different angle. This actor has been lit from high up on one side to simulate the fluorescent light above him.

**5** In your editing software, place two copies of the clip in the timeline. Adjust the opacity of the upper clip to 50 percent. Apply a Color Correction filter, and raise the levels of the Whites and Mids sliders.

**6** To produce the flicker, use the Pen tool to drag the opacity up and down several times for each second of footage. You can take the opacity right down to zero or up to about 80 percent.

# Particles of Light

Swirling particles of light are popular in title sequences, but you usually need complex software to generate them. This technique gives you a quick and easy way to generate your own particles with nothing more than cheap confetti.

Filmed against black and slowed down, these brightly lit particles look like a stunning, expensive effect. Shoot several different kinds of particle so you can build many different layers into your final image.

 Set up a black cloth and position your lamp so that a beam of light passes in front of it. No light from your lamp should strike the cloth itself.

**1** You can use any small, confetti-like material for this effect, but you get better results if the particles are metallic. Purchase more than you think you'll use, as it may take a few attempts to get exactly the result you want.

**3** Don't leave your camera on autofocus, or it will keep changing focus as you drop the confetti through the light beam. Instead, get an assistant to hold a packet of the confetti in the light beam and adjust your focus manually.

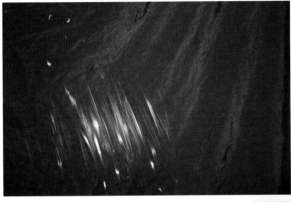

**4** Turn out all the other lights, otherwise the black cloth will show up as gray. Make sure you adjust the exposure manually, or your camera may compensate for the darkness, making the black cloth visible. To get the exposure right, keep closing the iris until you can't see the black cloth, then drop some confetti and test whether it shows up in the light beam.

**5** When you're ready, sprinkle the confetti into the light beam. Make sure your hand doesn't enter the shot.

**6** Load the clips into your software and layer them over your background footage, with the Composite Mode set to Add. You can slow down the clips to 50 percent, or even less, to make the particles move slowly. You can also resize the clips and adjust their position to alter how much of the background image shows through. When you add two or more clips, you might want to reduce the opacity of your particle clips to about 75 percent, so they don't obscure everything else.

**7** This is an ideal composition, with swirling particles of light above and below the main image, and the titles sandwiched in the space between.

DEADLINE DAY
a film by Christopher Kenworthy

91

# Water Camera

With careful positioning of your camera and clever use of focus, you can shoot your actor through the reflection in a puddle. This is one of the most powerful effects you can create with a basic video camera, and is ideal for music videos.

Keep the water far away from cables and lights at all times. When you shoot, the image will appear to be upside down, so don't forget that it will need to be flipped in your software later on.

**1** Find an outdoor area where you can make a puddle. Most flat surfaces will hold water for a short time, but it's better to find a small dip in the ground, where the water can collect. Your camera and tripod should be set up over the puddle, pointing down into the water.

**2** Although you can shoot puddle shots in the day, you need to shade the puddle, and add lots of bright light on the actor. The more efficient way is to shoot as soon as it gets dark. Position your movie light away from the puddle, illuminating your actor brightly. Try to keep the light from falling directly onto the puddle, where it might create unwanted reflections.

**3** Let's assume for a moment that you are shooting a music video. Your actor should gaze into the puddle, and try to look directly at the camera's reflection and sing at the same time. If she has difficulty seeing the camera in the reflection, hold a piece of bright white paper next to the camera to make it easier for her to pick out.

**4** From the other side of the puddle, your camera should show the actor, upside down, reflected in the puddle. Use a wide lens to set up, because it's easier to see the reflection this way.

**5** Once everything is aligned, you can zoom in on the puddle. Ideally, there should be areas of wet ground around the puddle to add detail to the image. Focus on the ground, allowing the actor to become a bright blur. This is how your shot begins. The audience will think they are looking at a brightly lit patch of wet ground.

**6** After a few seconds, use the manual focus to bring the actor into sharp focus. The foreground of the puddle will blur, and the actor's image will be distorted slightly as the water moves.

**7** In your editing software you will need to flip the image vertically. The resulting image is a fantastic combination of water and light.

93

# Blood Impact

When your character gets shot, you want to create a strong reaction in the viewer. You can achieve this with a combination of good acting, sound effects, and a visible wound.

Special effects such as this take a lot of time and care to set up, and are on screen for only a fraction of a second. It's worth the effort, because a strong visual like this tells the story clearly. Take your time to set up and practice this technique before you come to the shoot.

**2** Pour your fake blood into a balloon, and secure this to the end of a piece of tubing. You can use rubber bands to hold the balloon in place.

**1** There are many ways to create fake blood, but this method creates a substance that looks good on video. Mix glucose syrup with water and red food coloring. This won't look like real blood to you, but when filmed it creates the right impression. Don't use too much glucose syrup or the mixture will become too sticky. You want the consistency to be slightly thicker than water.

**3** Secure the blood bag to your actor's chest or back with surgical tape (found in most first aid kits). You can also secure the tubing every few inches, to make sure it doesn't drag on the bag or show through clothing.

**4** Lift the balloon up so that the blood falls away from the tip. Carefully snip the end of the balloon off with scissors. If you let go now, you'll get fake blood everywhere, so immediately tape the open end of the balloon to the actor's chest.

**5** Run the tubing down through your actor's clothes, and out through a trouser leg. Your assistant will keep hold of one end, ready to blow through the tube. Alternatively, if you have one, a bulb syringe can also work well.

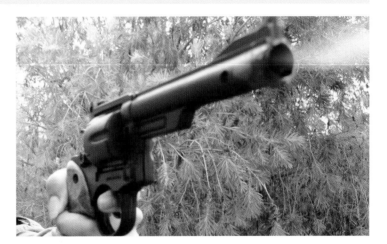

**6** To make it really clear that your character is being shot, you'll probably want to show the shooter taking aim and firing. You can create a rush of smoke from the gun by using the Ultra Cold technique (see page 122).

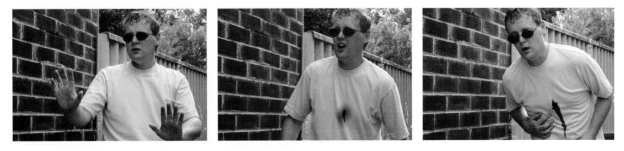

**7** If you want to see the blood spray out rather than just soak through, cut a small hole in the clothing over the bag. Once the shot has begun, call "Fire," to cue your assistant to blow through the tube as hard as possible. After a moment, the blood bag will splash open. Tell your actor not to react to your call, but to wait until the bag explodes, as it can take a second or two to work. It may take a few attempts to get the exact look you want, so rehearse without the blood first, and make sure you have spare clothes and extra equipment to repeat the setup if necessary.

# Knife Impact

Stabbings are dangerous to shoot, especially when a knife is being thrown around. To make this stunt safe, you need to use a few simple tricks that will make the technique look convincing.

As with all such effects, this takes some time to set up, and the end result will be greatly improved by good use of sound. While this is a technical shot, don't let yourself become too obsessed with the technicalities. Remember that the actor's performance is as important as anything you can create with the effect.

**1** Purchase two identical knives, and carefully remove the blade from one of them. The handle will be strapped to your actor, to make it look as though the blade has stuck into his flesh.

**2** Push the handle of the knife into a small piece of modeling clay, and press the clay tightly against the plastic to make it secure. There should be no wobble in the handle at all.

**3** Cut a tiny hole in the clothing you want to pierce with the knife. This hole should be smaller than the knife handle. It's better to squeeze the blade through a tight hole than to risk showing any of the modeling clay through a larger hole.

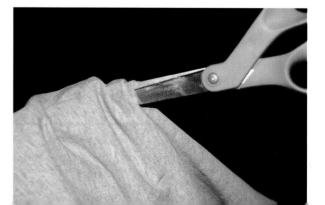

**4** Tape the modeling clay and knife handle to your actor's chest or back. You should position this so that it matches the hole in the clothing. Make adjustments before you tape the handle securely.

**5** When the clothing is pulled down over the knife handle, it should fit snugly without any gaps. The clothing should be loose enough so that the form of the modeling clay doesn't show at all.

**6** One way to film this is to shoot an actor throwing a knife into an empty space, and using the Whip Cut to connect this to a shot of the actor being hit. However, it's not ideal to have an actor throw a knife under any circumstances. One solution is to show the actor brandishing the knife. As he pulls back to throw, he can drop the knife behind him (unseen by the camera). When he throws his hand forward, you pan rapidly to the left, where the other actor is standing with the knife in his chest.

**7** To the audience, it will look as though the knife has been thrown across the room and become embedded in flesh. After a few moments, you can add fake blood, and shoot from another angle to complete the effect.

# Passing Through a Keyhole

A few years ago, movie-makers started moving cameras in new and unique ways. Cameras appeared to be able to fly through walls, under furniture, and best of all, straight through keyholes. In reality, no camera can do such a thing: the result is achieved with the help of a visual effect.

This technique lets your camera peer through a keyhole, then move forward, passing through the keyhole and into the room beyond. Take care to light everything well, and the audience will assume you have discovered a magical way to move your camera.

**1** Set up a piece of bright green card behind your keyhole. The keyhole should be large enough to see through clearly, and so that the green shows up quite brightly. Don't put the card so close to the door that it can't be lit. Position a lamp in such a way that the card is lit by an even spread of light.

**2** Your camera move can begin from the side or slightly above, but in this example the camera flies straight toward the door, directing its lens through the keyhole the entire time. You can use a dolly, but might find it easier to get the precision you want by doing this handheld, as long as you keep the movement smooth.

**3** Try not to alter your pace as you approach the door, or this will look like hesitation in the final footage. Keep moving forward until the green almost fills the screen. Get as close as you can without actually touching the door.

**4** You can shoot your interior anywhere you like—it doesn't have to be a room on the other side of your keyhole. Make sure it's well-lit and visually interesting. Hold your camera at the same height as the keyhole, and move forward at the same pace as accurately as you can.

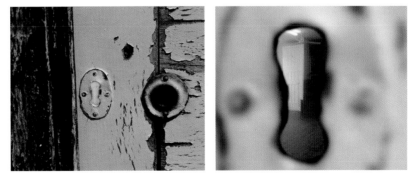

**5** With your editing software, apply a Greenscreen or Chroma Key filter to the keyhole clip. This clip should be placed above the background footage. You will instantly see the room through the keyhole.

**6** Once the basic effect is complete, you can adjust the speed and relative timing of the clips to make the connection between them smooth. About one second before the keyhole clip comes to an end, click the Keyframe button, then, at the end of the clip, increase the Scale to 200 percent. This will increase the size of the hole until it fills the screen. Test the result, and if you feel that the hole increases too suddenly or too slowly, adjust the final Scale value.

# Gunsights and Binoculars

If you want to see your character lined up in a gunsight or being spied on with binoculars, you don't need expensive lens attachments. The same effect can be achieved by blending black-and-white outlines with your carefully shot footage.

When shooting your footage, don't deliberately make the camera wobble to create the handheld look, but don't put the camera on a tripod either. The best approach is to hold the camera as still as you can, and let the natural wobble create the required look.

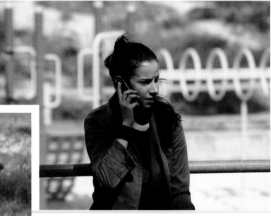

 **2** This setup means that when you zoom in on your actor, he or she is sharp, but the background appears blurred. This is a good approximation of the effect you get when looking through telescopic gunsights.

**1** To create the gunsight look, you'll need to position your actor some distance from the camera, with a background that's also some distance away.

**3** Using software such as Adobe Photoshop, or with pen and paper, draw a black-and-white gunsight. If you use Photoshop, export this image as a JPEG. If you use pen and paper, scan this into your computer, or film it with your DV camera.

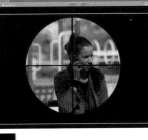

**4** Drag both clips to the timeline in your editing software, with the gunsight on top. Change the blending mode (or Composite mode) to Add, Subtract, or Multiply. You get different effects with different software, but you want the image to appear as shown here. Click the Keyframe button, and drag the gunsight frame to a slightly different position every few frames. This will look as though the shooter is attempting to line up on the character's head. If your software supports motion blur, switch it on so that the moving gunsight appears blurred when it moves.

**5** The setup for the binocular effect is similar. Your initial footage should be shot with as much space around the character as possible.

**6** When you look through real binoculars, you see just one circle, but it's accepted movie shorthand to see two circles overlapping. Draw this image, and import it to your software.

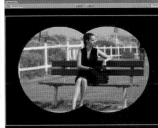

**7** Add both pieces of footage to the timeline, and change the blending mode until you get the desired look.

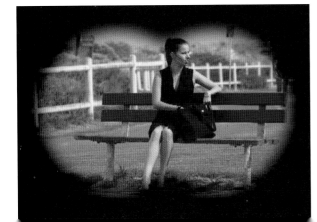

**8** Add a Gaussian Blur to the binoculars layer to soften the edges. Again, this isn't quite realistic (with real binoculars you see a sharp edge), but this is accepted as a "real" look when watching a movie.

# Extreme Angles

Using extreme angles offers you a completely different approach to a scene. By pointing the camera either straight up or down, you can create powerful and original viewpoints.

Good directors are always trying to avoid clichés, and there are certain shots where this is particularly difficult. By using an extreme angle, you can almost always guarantee an original look. You can also use extreme angles to increase tension or change the mood.

**1** Although this shot looks good, it's a cliché. The camera has been set up with the widest lens possible, which makes the gun looks huge. This shot is somewhat overused, so be judicious with how you use it. The problem is that shooting from the side or from behind lacks impact.

**2** One solution is to shoot from an extreme angle. By getting down on the floor with the camera and pointing straight upward, you create a much more original image.

**3** In film and TV, people come through doors to begin or end scenes so often that it may be wise to try something new. This angle shows the whole of the character at once, as well as the room and the space outside. This looks better, but also makes the scene more sinister, so only use it if that's the effect you want. Make sure you're on a secure footing while you shoot.

**4** A good performance is vital, so it's tempting to keep the actor's face in shot at all times—such as in this shot, where the character is shown descending into a dark cellar. Unfortunately, the background is too busy and colorful for the shot to work.

**5** A more extreme angle, from above, works better. Although the actor's face isn't visible, you still capture the body language. You also get to see the darkness into which she's descending. It doesn't always work, but if you feel a shot lacks sparkle, try an extreme angle.

# Filters

Homemade filters can be used to create glow and mist effects. You can spend a fortune on expensive filters, or you can get excellent results by improvising your own. This also enables you to experiment with different materials to create unique looks.

Be aware that when you shoot with a filter over the lens, the effect is permanent for that shot. If you shoot with a glowing filter, the footage will always appear to glow. Used well, filters are a fantastic tool, but make sure you use them for a good reason.

**1** A nylon stocking can be strapped over your lens hood with rubber bands. Make sure the stocking is free of dust, and pulled tightly enough that it doesn't contain any wrinkles. Different colors of stockings will produce different results. Black is a good choice, because it softens the image without changing the color.

**2** The same street has been shot without the stocking filter, and then with the filter. The stocking makes the bright areas flare and glow, without actually reducing the sharpness of the image. This soft mist can add a romantic atmosphere, and is also good for close-ups on actors.

**3** When used at night, the effect of the stocking filter is particularly striking. The high contrast of lights against a black background makes the lights appear to glow in a bright mist.

**4** Another effective method is to take a piece of cheap, clear plastic, and run a knife over it until it is riddled with small scratches.

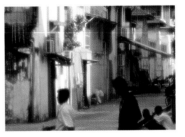

**5** The tiny scratches catch the light and create a starburst effect. Be wary of using a very wide lens with this type of filter, or the scratches may show up too clearly.

# Chase Scenes on Foot

When one character runs after another, you want to create a sense of fear and tension. To get a chase right, you need to use certain angles and techniques that can create the sense of pace and urgency so vital for the success of the shot.

In this example, we're simulating a situation in which the character is being chased by a wolf. The basic principles apply whether you're shooting a supernatural horror movie in the woods, or a murder mystery in which a killer is chasing somebody through city streets.

**1** The handheld technique works well for the point of view of the wolf. Here, the camera is carried low to the ground, with the lens brushing through the grass. Make sure you put a Skylight filter over the lens to prevent it from being scratched. Keep your knees bent and let the camera follow the level of the ground.

**2** By using a short lens (zoomed out as far as possible) your small, jogging steps look like fast, running movements. Trees and grass will appear to rush past the camera far faster than you are actually moving.

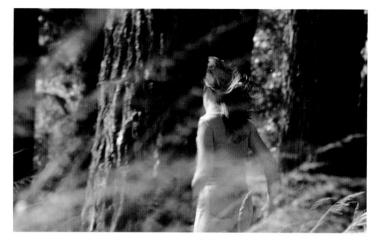

**3** In addition to seeing the wolf's point of view, we need to see the character running away. There are many different angles you can use, but this example works well at the beginning of a chase. Here, the actor is running between trees, some distance from the camera. The lens is zoomed out, and this, combined with the camera panning to follow the actor, causes everything else to blur. Even if your actor doesn't run fast, the rush of blurred trees will make it look fast.

**4** You can go in even closer and let the actor run into shot, then disappear behind a tree or out of frame faster than you can follow. This adds to the feeling of speed.

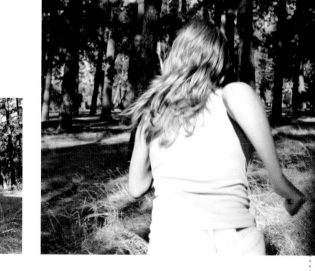

**5** Another strong effect can be created with a completely still camera. With the lens set as wide as possible, the actor runs into an empty frame and appears to rush off at great speed.

**6** You can also run with the actor to capture the sensation of trees rushing past. Make sure you watch where you are running. Aim the camera first, then concentrate on running, and check the shot afterwards. This shot isn't the point of view of the wolf, because it's too high up. It works particularly well toward the very end of the chase, especially if the wolf, or attacker, then jumps into frame unexpectedly, from the side.

# VISUAL EFFECTS

Bluescreen
Focusing on Empty Space
Spaceships
Laser Bolts
Robot Viewpoint
Explosions
Poltergeist
Miniature Worlds
Ultra-cold
X-ray Vision
UFO
Holograms
TV Burn-in
Film Look

# Bluescreen

Bluescreen work, or "chroma keying," enables you to place your actors in distant locations or imaginary places, such as a science-fiction universe. Shoot your actor in front of a bluescreen, then use your software to remove the blue. You can then put any image you like in the background.

Although this is primarily used in science-fiction, you can use it in other ways. Here, a beautiful sunset was shot several weeks before the main shoot, because the script required a shot of the actor at sunset. It's impossible to get your actors to turn up just because there's a good sunset, but you can easily use a bluescreen to drop them into the scene at a later date.

**2** Secure the bluescreen against a wall, either by draping it from a pole above or taping it to the walls. The cloth should hang as smoothly and evenly as possible.

**1** Buy several yards of blue material. You should choose a really bright blue. Bright green can also be used, and can be even better if you're working during the day, because daylight is quite blue. If you don't block out the daylight when working with a bluescreen, you may find your actors' faces also disappear when you remove the bluescreen with your software.

**3** Most bluescreen shots just show the actor's head and shoulders, but if you want their feet to appear in the shot, make sure the bluescreen is draped all the way to the floor.

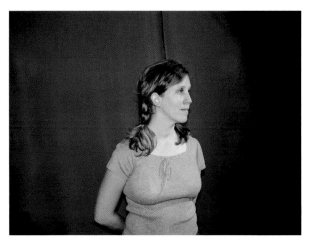

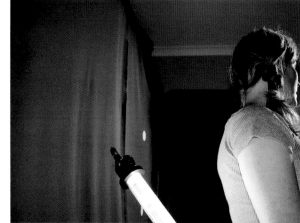

**4** Bring your actor onto the set and set up your lights. Your aim is to light the actor and screen as brightly as possible, without casting shadows onto the screen. Mount your lights as high up as you can, angled downward. You can light the screen from below with a fluorescent strip light.

**5** Portable fluorescent strips lights can be held behind your actor to lend a glow around the edge of his or her form. Although this won't be seen in the final shot, it helps to remove any blue light that may spill out from the screen.

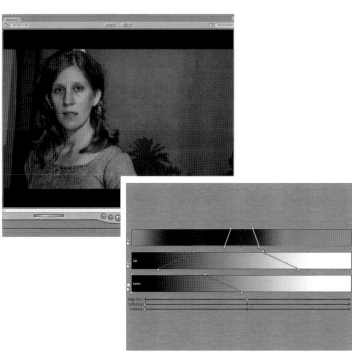

**7** The final layer with the actor can be made to match the background by using a Color Correction filter. Use the Feather and Edge Thinning controls in the Bluescreen filter to get rid of any remaining blue fringe around the actor, without leaving a hard edge.

**6** When you're working on the footage with your editing software, apply the Chroma key or Bluescreen filter and adjust the Tolerance and Levels until the blue vanishes. It's easier to see how good the results will look if you drop your background footage in beneath the bluescreen layer.

# Focusing on Empty Space

If you want to mix animation or 3D models with live action, one of the main difficulties is getting your actor to focus on empty space. It can look unconvincing. And, if you shoot your actors in a makeshift bluescreen studio, but want them to appear to be looking out at a landscape, you may have problems if they only have a nearby wall to focus on.

The way we focus on objects makes tiny differences in the way our eyes appear. This technique ensures that an actor's eyes focus correctly during an effects shot.

 **1** In this example the actor is pretending to focus on a dragonfly that is hovering in front of her. She is being shot against a bluescreen, and, although she tries to focus on empty space, she is actually focusing on the distant wall.

**2** This shot was created by filming a model dragonfly in front of a bluescreen. This clip was then layered together with a landscape and the bluescreen shot of the actress. Although the dragonfly has been placed in front of the actor, the audience can tell she's not really looking at it.

**3** The solution is to hang a cotton thread in front of your actor. Take a piece of black or blue thread, and stick it to the ceiling with tape.

**4** The cotton is too thin to show up on screen, and will vanish when you apply the Bluescreen filter. The actor focuses on the thread throughout the shot. If you want your dragonfly to move, get your actor to shift her gaze up and down the thread. If you want even more movement, you can get an assistant to move the thread around on the end of a rod, making sure the assistant—and the rod—stays out of shot.

**5** The end result is much more convincing, because the actor's eyes now have the appearance of being focused on something nearby.

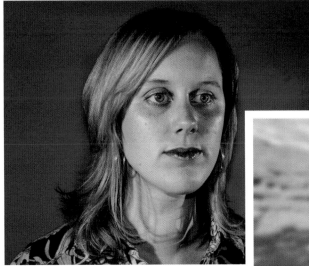

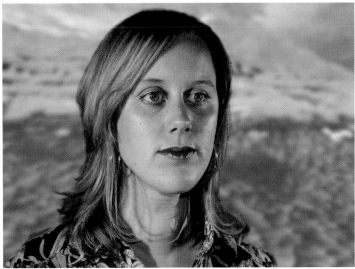

**6** If you want to create a faraway gaze, as though your actor is staring at the horizon, shoot outdoors with a greenscreen background. You should use green rather than blue because daylight is quite blue and will confuse your software's Bluescreen filter. Your actor should stare at the real horizon, which gives her exactly the look that's required.

# Spaceships

Convincing spaceship shots are relatively easy to achieve, even if you've never built a model before. With nothing more than spray paint and pieces of junk, you can create a spaceship that looks good on screen.

Modern editing software makes it easy to create the illusion that your spaceship is enormous, traveling through space at great speed. Although this example shows the ship rushing toward the camera, you can easily adapt the technique so that the ship passes overhead, or swoops around in an arc.

**1** Gather together a collection of cheap plastic models and junk, from which you can assemble your model. A toy laser gun, some military toys, and a door handle are all that was required for this model.

**2** You may find it helps to use surgical tape to hold your model upright while you assemble the pieces. Use a quick-drying glue to hold everything together. At this stage your model will look like a piece of junk, so try to imagine how it will look when painted. Although you can paint each section individually, the quickest method is often the most appealing. Simply spray the entire model with a gray or metallic paint, and you will make it look like an expensive movie model.

**3** Position your model in front of a bluescreen, and light it so that all shadows are soft. If the shadows are too harsh, they will reduce your ability to remove the bluescreen later on. This model has been placed on a box, which is underneath the blue cloth. It is held up with nails, which have been placed behind the model and pushed into the box, so that they will remain unseen on screen.

**4** Although you want it to look as though the spaceship is swooping toward the camera, you don't move the spaceship itself. To do so would risk damaging your model. Also, you get a much more convincing final effect when you move the camera toward the ship and swoop past it.

**5** Before you load the clips into your software, check that there are no extraneous shadows on the screen, and that the ship remains well lit throughout the shot. Camera shake should be kept to a minimum.

**6** Apply a Bluescreen or Chroma key filter to your footage, and layer it over a star field background. You can create a star field by filming black paper with white speckles of paint. When your work is complete, and suitable sound effects added, it will look as though the camera is stationary, and that the spaceship is sweeping past.

# Laser Bolts

A science-fiction battle wouldn't be complete without a few laser bolts. This is a special effect that used to be reserved for the major studios, but you can now get the same results with your desktop software.

The method shown here can also be applied to spaceship shots as well. In theory, you could shoot your spaceship model six times, and add a hundred laser bolts, to create a massive space battle. Or you can shoot crowds of people, all firing lasers.

**1** You can shoot your actor against a bluescreen, but this isn't essential for the laser effect. However, it's vital that your actor mimes the action of shooting the gun. This gives you a way to time your laser bolts.

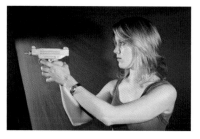

**2** To create the laser effect, film a flashlight in a dark room. You should wear black clothing and gloves, ensuring that no light spills onto the walls. Move the flashlight from left to right across the screen.

**3** Before you apply the laser effect, you should edit and complete the shot. Save time by making certain which shots need to be worked on before you begin. Complete your edit and color correction, and then prepare to add the laser bolts.

**4** Import the laser bolt footage, and speed it up by 400 percent. This will make the bolt travel across the frame in a fraction of a second. You should also scale the image down, so that it matches the size of your laser gun.

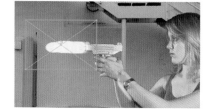

**5** Apply a Color Correction filter to the laser layer, and adjust until you get a brightly colored glowing laser look. Position the laser bolt clip so that it appears exactly when your actor makes the shooting motion.

**6** Click the Keyframe button, and move six or seven frames forward through the sequence, then drag the laser layer off the screen. Your laser bolt now moves across its own frame, as the frame itself slides off screen. This looks like a rapid blast of light.

# Robot Viewpoint

Robots and cyborgs are a popular feature of science-fiction movies, popularized in recent years by movies such as *The Terminator*. To get inside the head of a robot or cyborg character, directors sometimes show the robot's point of view: often a grainy image with moving text on it. This looks like an advanced effect, but is easy to achieve.

These shots are useful when your robot is tracking somebody, or searching for something. Rather than showing the robot looking around, you can present the scene from the robot's perspective, which gives your audience some insight into the character.

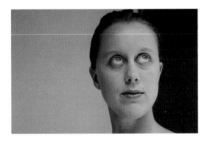

**1** A wide shot of the character walking down the street sets the scene. Shoot a close-up of the cyborg when it shifts its gaze from one place to another.

**2** You can shoot your POV shot anywhere you like, but try to shoot at an angle that matches the angle of the robot's viewpoint. This robot is looking up and across the street; so is the point of view.

**3** Load the clip into your software and duplicate it. Apply the Find Edges filter to the uppermost clip, and change the compositing mode to Add. Use a Color Correction filter to differentiate the colors.

**4** Use the Text tool to add layers of colored text to the image, set to the Add Composite mode. It's quite time-consuming, but you get better results if you add new pieces of text over the course of the shot.

**5** Position some shapes, then click the Keyframe button and move a few frames forward. Now drag them to another position. This makes it look as though the robot is scanning through the image.

**6** When your robot finds what it's looking for, change the color of your shapes to red, and put in new text, such as "Target Locked." Experiment with zooms, blurring, color shifts, and sound effects.

# Explosions

Real movie explosions are dangerous, expensive, and, most of the time, unnecessary. You can create a convincing explosion with well-lit water, and add it to your footage later. You'll need to choose a good explosion sound effect to make this work well, and there are many variations available for free on the Internet.

This technique requires the use of a large, clean mirror so that you can shoot the water explosion without risking damage to your camera. You will, however, wet the mirror each time you perform the effect, so have plenty of towels on hand so you can wipe the mirror dry and shoot again.

**1** The balloon used in this example is red, but you should use a black balloon. A black balloon won't show up in the finished shot, ensuring that only the brightly lit water is visible. This combination of air and water yields a good explosion, but you can experiment with other ratios. To create the illusion of a powerful explosion, fill the balloon halfway with water, and then add enough air to fill it up until it is close to bursting.

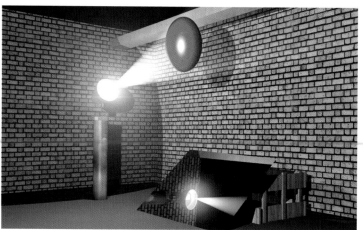

**2** To create this effect, you need to work in a dark, enclosed space. Lean the mirror against a wall or over a box, at a 45-degree angle to the floor. Suspend the balloon over the mirror. Your movie light should be positioned off to the side, aimed at the balloon. Keep the light far enough away that it won't be splashed when the balloon explodes.

**3** When you stand in front of the mirror, you should be able to see the balloon. (It shows up clearly in this example because the balloon is red.) You may find it easier to line up your camera on the balloon if you tape a brightly colored piece of paper to it. Remove the paper when you're ready to shoot.

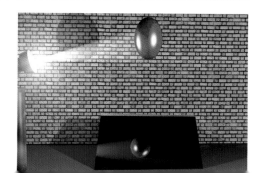

**4** Zoom in on the mirror so that nothing is visible except the balloon. Use the zoom rather than moving the camera forward to avoid any risk of getting water on the camera.

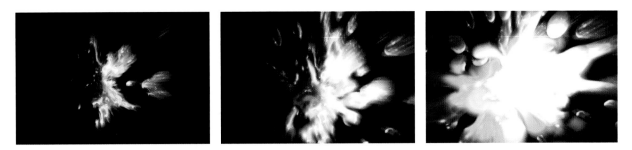

**5** You are going to need something to pop the balloon. The easiest method is to use black tape to attach a sharp nail or tack to a black stick, which won't be visible when you move it into frame. Start shooting and pop your balloon. When the balloon pops, brightly lit water will explode toward the camera, creating an authentic effect.

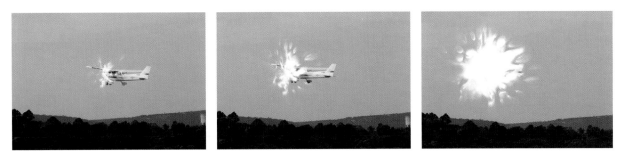

**6** In your editing software, layer the explosion footage over the airplane, car, spaceship, or building that you want to blow up. Use a Color Correction filter to shift the colors toward yellow. If the object is moving, you'll need to click the Keyframe button, and drag the explosion layer so that it matches the movement of the exploding object. Keep explosion shots brief, and cut them in with crowd reactions, or shots of people running away.

# Poltergeist

Although computer-generated visual effects can look superb, there's no substitute for a practical effect. With practical effects, what appears to happen on film is actually what happens on set. To create the impression of a poltergeist in a room, you need to show objects moving without human intervention.

The conventional—and easiest—way to achieve this shot is to tie a piece of thread to an object, and pull it, keeping the camera as far away as possible. However, a more original way is to use a pair of magnets, which means you avoid the possibility of a thread showing up on screen, and you have the flexibility of being able to move your object all over the table, rather than in just a single direction.

1 You can move any lightweight object, but let's take the example of a cup of coffee. You'll need a pair of large, powerful magnets. You may be able to salvage the appropriate magnets from a set of old loudspeakers. If not, magician supply stores (which can be found on the Internet) are a good resource. Place one of the magnets in your cup.

2 Your assistant should place the other magnet underneath the table. Use a table surface that's thin enough for the magnets to maintain a strong attraction. Be careful not to arrange the magnets so that they repel each other, or you may flip the cup over.

**3** It would require an extremely strong magnet to drag a full cup of coffee around. Use modeling clay to create a seal about half an inch below the rim. Let this dry completely.

**4** Pour cold coffee into the top of the cup. Use cold rather than hot coffee—you don't want to risk scalding anyone. Check that your clay seal is watertight and holding the coffee sufficiently, and then you can prepare to shoot.

**5** The beauty of this effect is that you can have an actor holding the cup before it is placed on the table. Once the cup has been put down, have your assistant drag the magnet beneath the table in several directions. The movement should be slow, or the liquid will slosh over the rim. Some spillage looks good, but be careful to avoid too much movement or you'll show the clay seal and the trick will be revealed.

# Miniature Worlds

You don't always need to find the perfect outdoor location for your movie. If you want to shoot a science-fiction movie on the surface of a far-off planet, all you need are some basic modeling materials to create your very own mountain ranges and Mars-style surface. Once shot, the landscapes can be merged with footage of your characters.

You'll need to be familiar with the bluescreen technique to get the most from this tutorial, but you don't need any previous modeling experience. Even the most basic model can look impressive when blended with shots of an actor and an interesting background.

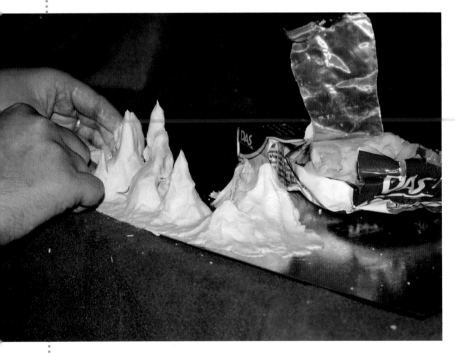

**2** If you want to add extra texture, sprinkle sand, soil, and other garden matter onto your model. Press some of this into the model before it dries, and then let the rest gather in the plains and valleys between the peaks.

**1** Use self-drying modeling clay such as Daz to create a mountain range on a flat surface. You don't need to be an experienced modelmaker. All you need to do is to make your planet surface or mountain ranges as interesting and craggy-looking as possible—and to smooth away any fingerprints afterward. A really textured surface will create realistic shadows, so be bold.

**3** Apply black or gray spray paint lightly, from a distance, so that small areas of the original color remain. Don't attempt to cover the entire model with paint, or try to blacken out the soil and sand. A mixture of colors is better than uniform black or gray.

 Set up your model in front of a brightly lit bluescreen, and position your camera at the same level as the model. Your movie light should be aimed at the model from one side, to create more interesting shadows and texture.

**5** In your editing software, use the Bluescreen filter to remove the blue background. Place this layer over your chosen sky footage.

**6** Shoot your actor in front of a bluescreen, and you are ready to combine all three of your images.

 Your creation will look more authentic if you add a Gaussian Blur. Not only does this hide any imperfections, but it replicates the effect of genuine depth of field—when the foreground actor is in focus, the background blurs. Apply Color Correction filters to all three layers, and adjust the settings until they blend seamlessly.

# Ultra-cold

In your movie, you might want to project the illusion that your actor is in a very cold location. To do this, you can add fake vapor to the image, so that each time the actor exhales, the audience can see her breath. This so convincingly imitates reality that your audience will have no idea that it's the result of some clever movie magic.

While costuming, dialog, and performance can help to create the impression of cold, visible vapor is absolute proof. Nobody will suspect that you actually filmed on a summer afternoon.

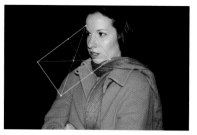

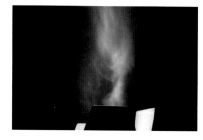

**1** Position your warmly dressed actor against a dark background, with her head turned slightly away from camera. This way, when you add the fake vapor, it will look as though it disperses straight from her mouth into the darkness.

**2** Next, let's create the vapor. One way to do this is to emit smoke from a smoke machine, over your movie light. Don't use huge jets of smoke. Fire your smoke machine away from the light, and then waft some of the smoke over toward it.

**3** Alternatively, you can boil a kettle in a dark room and point your movie light at the vapor as it comes out of the spout. Whichever method you use, make sure the background is as dark as possible.

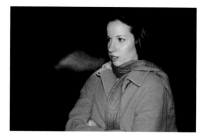

**4** In your software, add the vapor clip to the timeline, above the clip of your actor. Use the Crop tool to cut out any unwanted parts of the image. Rotate the layer so that the vapor comes from the actor's mouth.

**5** Set the Opacity to zero. Click the Keyframe button. Now move a few frames forward, changing the Opacity and Scale to 80 percent. Move forward again, and change the Opacity to zero and the Scale to 110.

**6** If there are hard edges where the vapor meets the side of the frame, adjust the Softness or Edge Feathering. To do this, copy the clip and paste it into the timeline when the actor breathes out.

# X-ray Vision

This great technique makes it seem as though your character is wearing X-ray glasses and can see through walls. In recent years, X-ray vision has become an increasingly popular effect in spy movies and science-fiction, and it is relatively easy to achieve.

The end result in this example creates an uneven hole in the wall, as though the character's eyes are scanning through it. You can easily apply other filters and effects to the X-ray vision layer to make it look more electronic or unusual.

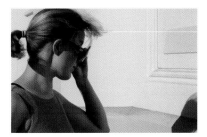

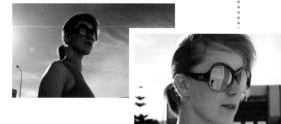

**1** Clearly establish that your actor is about to use X-ray vision. Here, the actor walks up to the wall, looks at it, then adjusts her glasses. As she does this, add a sound effect to imply that the glasses have been switched on.

**2** Shoot the wall from the point of view of your character. Select a wall with some texture and detail, as this is better than a completely blank wall. If the wall is too featureless, it will look like a blank screen.

**3** Shoot the actor's reaction as she looks at the wall. She will have to stand several feet back from the wall for you to be able to get the camera into position. Shoot both a wide shot and a close-up to increase your editing options.

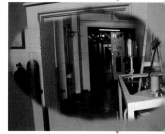

**4** Next, the background footage. Here, a long corridor contains sufficient detail for it to register clearly with the viewer. Whatever you show behind the wall, it should be something that's easily recognizable—such as a bomb with a ticking timer, or a safe filled with money.

**5** Place the wall clip over the background clip in your editing software, and apply a Matte filter. Use an Eight Point Matte to draw a rough hole in the wall. Raise the Feather Edges control to blur the hole.

**6** Apply a Desaturate filter to the background to distinguish it from everything else. You can change the shape of the hole over time by clicking the Keyframe button, moving forward a few frames, and dragging the Matte points to new positions. This makes it seem that your character is looking for something.

# UFO

You can create a convincing UFO shot without building a complex model. Most UFO footage doesn't depict a flying saucer, but a sphere of light or a glowing shape. By replicating this, your film will look more like authentic UFO footage.

Better still, this technique makes use of handheld video footage of an overhead airplane to provide an authentic sense of movement for your UFO as it flies across the frame.

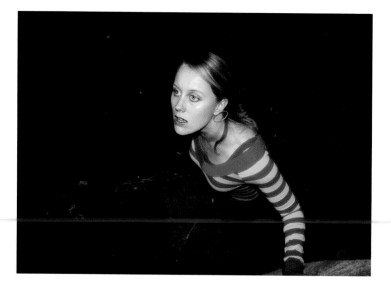

 **1** Film your actor looking up at the UFO. Shooting from above lets you show the actor's expression clearly. If you want to pretend that your UFO footage is a video recorded by your character, get your actor to hold a video camera and pretend he is following the UFO across the sky.

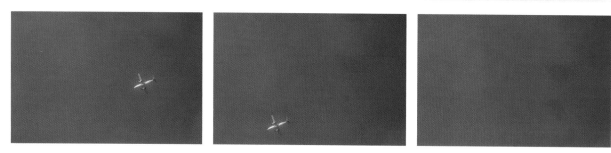

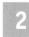 **2** When you get the opportunity, shoot an airplane flying overhead. If you've ever seen allegedly "real" footage of a UFO, the camera seems to trace the course of the UFO in a jerky manner as though it keeps losing focus. So, line up on the airplane, let it cross almost out of frame, then readjust the camera so that it's centered in the frame once more. This creates the impression that the videographer is chasing the UFO as it flies overhead.

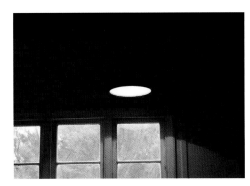

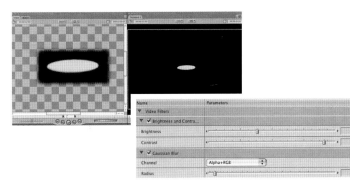

**3** One way to create a UFO is to shoot a lampshade from the side. The bright area forms a cigar shape of brightness. This is one such example, but you will find that any bright, interesting shape will produce equally effective results.

**4** Import the UFO clip into your footage. Use the Crop tool to remove the surrounding image, then apply the Brightness and Contrast filter, adjusting until you get a bright shape against a black background. Apply a Gaussian Blur to soften the UFO slightly.

**5** Position the UFO over the airplane, and change the Rotation and Scale until it obscures it. Click the Keyframe button.

**6** Move forward about half a second and drag the UFO until it again covers the airplane. Do this every half-second or so. Watch the footage again, and if the airplane appears from behind the UFO at any point, go to that frame and drag the UFO until the airplane is once again obscured.

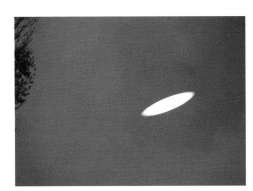

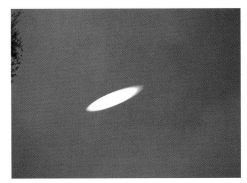

**7** The UFO now appears to fly in a straight line across the sky, while a handheld camera tries to keep up. This result is far more convincing than shots taken with a camera on a tripod.

# Holograms

Make your actor appear as a glowing, blue hologram projection. This stunning effect is remarkably easy to achieve. Although it looks like an advanced visual effect, you can get good results with careful planning and patience.

On a Hollywood set, this sort of shot is usually done with motion control cameras, which are like robotic arms with a camera attached. However, the technique described here has been used on major feature films—and is known as "poor man's motion control." It's ideal when time and money are running short.

 Set up your actor in front of a bluescreen, lit brightly, making sure you avoid projecting shadows onto the bluescreen.

**2** By moving the camera around your actor, you create a powerful impression of a 3D hologram. Mark out a circle on the floor, and move around the actor, pointing the camera directly at her as you shoot.

 Your actor should look straight ahead, as though communicating with another character. You can also record dialog during this take.

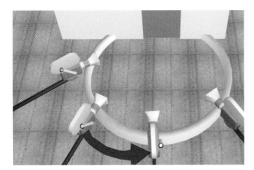

**4** You need to repeat the same camera move when you shoot whatever you've chosen for the background. Wherever you shoot, try to copy the same arc at exactly the same speed. When the two pieces of footage are put together, the camera will appear to circle around a hologram in a real place.

**5** In this example, a graffiti-sprayed wall was shot and a stopwatch was used to match the timing. You should also make sure that as you circle, you point the camera at the center of the circle. In other words, aim the camera at the point where the actor would be standing if she was in the location.

**6** Import the bluescreen sequence into your editing software, and use the Bluescreen filter to remove the background.

**7** Import the background layer, and adjust the speed of the clip as required so that both sequences move at the same rate. Set the actor's layer to the Add blending mode, to make it transparent.

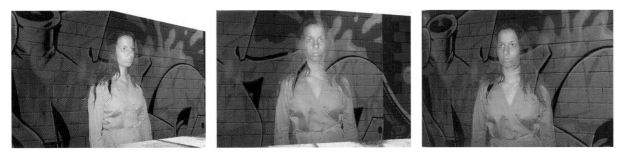

**8** To create the final effect, use a variety of filters to create the electronic look. Color Correction, Blur, and Distortion filters can all add to the feeling of holographic projection.

# TV Burn-in

Whenever you shoot a television screen with a video camera, the TV images look distorted and ugly. The screen flickers, the images appear to be overly blue, and you can't see a clear image. Whether your TV is meant to be in the background, or is an integral part of the scene, this needs to be corrected.

By "burning in" your own footage to the TV screen in your editing software, you increase the brightness and clarity of the TV image. This also gives you the opportunity to choose the TV footage long after the shoot has taken place.

**2** Place your camera on a tripod and shoot the television. If you shoot with the television switched off, you may find it easier to blend your footage into the image. You will also find that having the television switched on projects a blue glow over the surrounding furniture. This can add a touch of realism, but it can also make matching your footage to the image more difficult. This is a matter of choice, so do experiment.

**1** First, you will need to create the footage that will appear on the TV screen. Even if the TV image isn't central to your story you'll have to use original footage because copyright law prevents you from showing actual programs.

**3** If the TV image is important—such as when a character is seeing a news report that's vital to the story—you will need to shoot your actor watching the television.

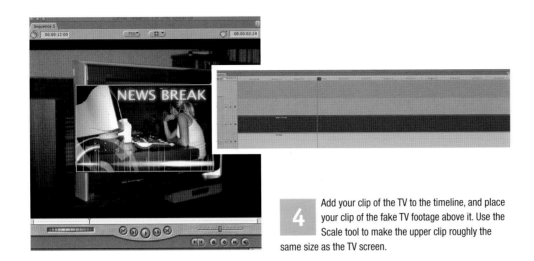

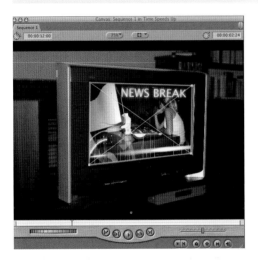

**4** Add your clip of the TV to the timeline, and place your clip of the fake TV footage above it. Use the Scale tool to make the upper clip roughly the same size as the TV screen.

**5** Use the Distort tool to drag each corner of the TV layer until it meets with each corner of the TV screen. When you play the clip back, it will look as though your footage is playing on the TV screen. To make the image look more realistic, use the Brightness and Contrast filter to lower the brightness of the image.

**6** The same effect can be used to fake computer screen readouts. Rather than trying to film what's actually on the screen, create the image in your software and paste it over the monitor screen.

**7** If you want to show people in the same shot as the screen, be certain to make sure they don't overlap the screen. If they do, as in this over-the-shoulder shot, the illusion will be destroyed.

# Film Look

In terms of image quality, number of frames per second, and color depth, there are many differences between film and video. Film is still considered to be the superior medium, although the very best high-definition video cameras are approaching the quality of film. In the meantime, most video filmmakers want their footage to look as much like film as possible.

To get video to look like film, your first job is to light your scenes as well as you can. Then you can apply this technique to add a "film look" to your footage. It takes some of the sharpness of video away—each frame of film appears to have a slight motion blur, where moving objects "smear" over the frame.

 **1** Import the footage into your timeline, and place one copy on top of the other. It's best to do this when your film is complete, rather than treating each clip separately.

**2** Reduce the Opacity of the upper clip to 50 percent. The image won't appear to change at all.

**3** Add a Deinterlace filter to each layer. The Deinterlace filter has a Field setting, which can be set to Lower (Even) or Upper (Odd). Set one clip to Lower (Even), and the other to Upper (Odd) —it doesn't matter which way around you do this, as long as the filter on each clip has a different setting.

**4** The footage may not look any different on your computer screen, but when you show this footage on a television, either by playing it back through your camera or burning to a DVD, the finished footage will have the slight motion blurring of film.

**5** Film often has a richer range of colors than video, and you can simulate this by increasing the saturation of your footage. Apply a Hue/Saturation filter, and raise the saturation slightly. Don't overdo this effect or the colors will bleed into each other. You will need to apply this filter to each shot of your film separately, as they will all have different color ranges.

**6** The opposite approach can also work, depending on what sort of footage you're using. Many feature films are shot with a deliberately limited range of colors. You can use a Hue/Saturation filter to reduce the color saturation. Try both techniques and see which works best for your footage.

**7** Film has a fine grain, which is almost invisible. For some footage, fake film grain can help to create the illusion that the clip was shot on film. Duplicate your clip, and reduce the Opacity of the upper clip to 50 percent. Then apply a Noise filter, followed by a Gaussian Blur. When played back, you will have added a fine grain to your image.

# SAFE STUNTS

Leaping Across a Big Gap
Punches
Breaking Down a Door
Smashing Objects

# Leaping Across a Big Gap

A shot of someone leaping between tall buildings is a staple in popular action/adventure movies. Although it looks life-threatening, you can create this effect at home without anyone risking life or limb. By choosing your shots carefully and editing them together well, the audience will be on the edge of their seats as the scene unfolds.

While this is still not a stunt by ordinary standards, it still requires more leaping about than most scenes, so you should put safety first. Only use actors who are fit and willing to do what you ask. Everybody should be clear about what's required of them before you start shooting.

**1** Characters usually leap across large gaps during chase scenes. To set up the illusion, you first need to show that there's a big gap to be crossed. Since your actor won't actually be leaping from building to building, the way to do this is to have her approach the edge, stop, and look down. This can be shot at ground level, looking over any wall.

**2** Film a point-of-view shot, looking down. You can shoot from much higher up, to make it look like a jump between skyscrapers, or—as shown here—just two stories up. Show the actor moving back to take a run-up.

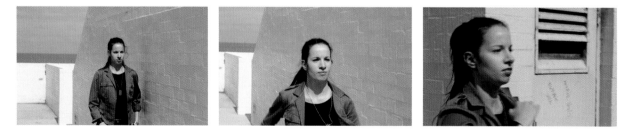

**3** The roof you use needn't be high up at all. This roof is only one story high, and is surrounded by a wall, so there is no danger to the actor. Note that the background reveals no clues to the building's true height.

**4** By taking the camera even higher than the actor, you can strengthen the illusion of being high up on a roof. Although this building is at ground level, it looks like a rooftop. You'll need to keep the camera still to avoid giving away the true nature of the location. Have the actor run through the frame.

**5** Set up your video camera between two bricks, pointing upwards. No tripod can take your camera low enough, so this is a good way to secure it on the ground.

**6** Your actor should leap directly over the camera, being careful not to clip the lens on take-off or landing.

**8** Shoot footage of your actor's feet leaping off and landing, and cut these images on either side of the leap.

**7** This shot of the actor passing overhead can be cut into the middle of the sequence, to create the impression that she has leapt across a huge gap.

**9** For the landing, all your actor needs to do is run up and jump into frame in another location. When cut together with the run up, leaping feet, a jump through the air, and landing feet, the illusion is complete.

# Punches

Carefully staged fighting is used all the time in the movies so that actors can throw a punch without causing any harm. The simple use of effective camera angles and carefully timed performances can create a powerful result.

When you shoot a stage fight, try to shoot one or two punches at a time and then cut to another angle. This is much safer than trying to shoot a whole sequence at one time. Get your actors to rehearse carefully and slowly until you are confident they can perform the fight without the risk of injury.

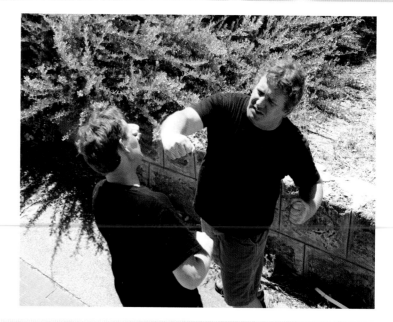

**1** The actor who is in the attacking position punches the air in an arc, past the other actor's face. Your actor doesn't need to make the punch come too close to the face. In fact, it's more important to ensure there's a good gap, and to get the timing right. The actor being attacked should recoil at the moment of supposed impact.

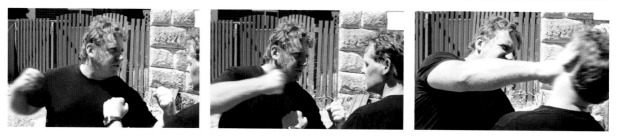

**2** Shoot the scene from the same level as your actors so the first actor's fist appears to pass behind the face of the other. Shoot with a long lens (zoomed out). This shortens the apparent distance between the fist and the face, so that even when the punch passes the face several inches away, it appears to make contact.

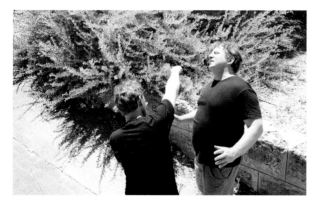

**3** This version of the punch is even more bold, because the fist crosses on the camera-side of the face. Here, a substantial gap has been left between the fist and the face, to ensure safety.

**4** When shot with a long lens, the impression is that the fist swipes in from the side, and knocks the other actor backward. Although your actors should always aim for safety first, tell them that speed is more important than proximity. A fast punch at a safe distance is better than a slow one close to the face.

**5** To help you edit the sequence together, shoot lots of close-ups of fists impacting on the body. Your actors don't need to hit each other. Instead, start the shot with the actor's fist on the other actor's body, and when you call action, the fist should be pulled backward. These small movements are good enough to convince the audience that real contact is being made, as long as you add good sound effects.

**6** If you want to show one character being knocked out, you can achieve the effect by shooting as though from the point of view of the character. The actor winds up a punch, and delivers it straight to camera. The shorter the lens you use, the faster the punch will appear, but your actor will also have to land the punch quite close to the camera for the fist to fill the screen. With a slightly longer lens (zoomed out), the fist will fill the screen before it gets close to the lens. For emphasis, have the cameraman fall backward once the punch is delivered. When the footage is loaded into your software, adjust the Opacity gradually until it reaches zero, to show your character passing out.

# Breaking Down a Door

Breaking down a door looks fantastic on screen, but unless you plan carefully, this stunt can cause injury. To make it as safe as possible, you won't actually need to burst through a closed door. With careful cutting, your actor only needs to gently push through an open door.

As long as the audience believes the door is firmly closed and then broken down, that is all that matters. You might find that when it's first edited, the effect doesn't look realistic. Tighten the edit even further, so that each clip is short and punchy, and it will work.

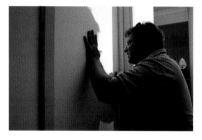

**1** It's important to establish that the door is locked. It can also help to remind the audience why the character wants to get through the door. Show your actor banging on the door in frustration.

**2** To emphasize the difficulty the character is having, show the door from the inside of the room. Get your actor to bang on the door. This should make the door vibrate enough to show up on camera.

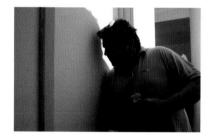

**3** Before the actual breakthrough, you can show some failed attempts to push it open. Your actor can pretend to ram the door, but this should be mimed—there should be no actual pressure on the door.

**4** Although the final burst through the door will be gentle, you should still put some padding in place to prevent the door impacting too heavily on the interior of the room. Ordinary pillows will do the job.

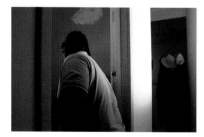

**5** Your actor should open the door slightly, then when you begin shooting, push through. You will only use a fraction of this shot, so don't worry if the shot looks fake. When cut down and combined with the other shots, it will work.

**6** Set up your camera away from the door, and get your actor to bust through. Tell him to be ready for the door to bounce back. Edit so that the shots of him busting through are just a few frames long, and then cut straight to the rest of the scene.

# Smashing Objects

Smashing objects such as bottles or lamps is risky, but there are simple ways to make it look realistic without endangering anyone. By combining different angles with sound effects, the audience will never suspect that the object was smashed in completely safe conditions.

Although it's sometimes tempting to get your actors to smash an object for real, there are too many risks from flying debris, and you reduce your opportunity to shoot different takes. This approach lets you perfect the actor's performance before you break the object.

**1** In the first shot, establish that your actor and the object are in the same place. If your actor is about to smash a bottle, lamp, or break a piggy bank open, get the actor to hold the lamp, bottle, or piggy bank.

**2** If the actor is about to throw something, you don't need a close-up. However, if the actor is going to smash the object with a hammer, a close-up can help clarify what's about to happen.

**3** Your actor should make the motion of smashing the object. In this example, the object is off screen, to give the actor more room to swing. The results will be better if your actor has good miming skills.

**4** When you're happy with the performance, you can break the object safely. A reliable method is to put the object in a plastic bag before smashing it. Wear safety goggles.

**5** Put the smashed object back in place. In this example, the actor pulls the hammer back when the shot begins, as though pulling back from the blow.

**6** Always shoot a close-up of the face as a cutaway from a different angle. This means you can show the swing of the hammer, the actor's close-up, then the hammer being pulled away. The audience will think they saw the piggy bank being smashed.

# ADVANCED EFFECTS

Computer Screen Projections
Wall Projections
Shadows on the Wall
Time Travel without an actor
Time Travel with an actor

# Computer Screen Projections

We've all seen this scene in a movie, in which someone is working on a computer (usually at great speed, trying to steal some information), and the screen is projected onto the character's face. This technique is remarkably easy to achieve. All you need to create this effect is a simple video projector.

In reality, a computer screen would not show up on a person's face in this way, but the audience buys it because it has become a convention. Computer-based scenes can be a little uninspiring visually, so this is a good way to make the moment interesting.

**1** Shoot an over-the-shoulder shot of your actor typing, without the computer screen in the shot. This can be a brief shot as she logs on or begins to search for information.

**2** Shoot your actor from the front, with the camera on a tripod. Your camera should be at the same height as your actor's head.

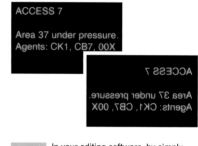

**3** In your editing software, by simply typing text over a black background and using a Color Correction filter, you can create a convincing computer screen. When your clip is completed, flip it horizontally.

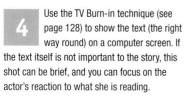

**4** Use the TV Burn-in technique (see page 128) to show the text (the right way round) on a computer screen. If the text itself is not important to the story, this shot can be brief, and you can focus on the actor's reaction to what she is reading.

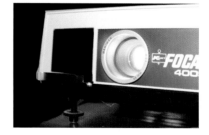

**5** Use the Print To Tape feature of your editing software to export your reversed computer screen footage to your video camera, and then copy it to a VHS videotape in your VCR. Connect your VCR to a video projector, and project at your actor's face.

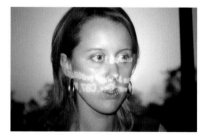

**6** The result will be an image of glowing text that wraps around your actor's face as she acts. You can apply a Color Correction filter to the finished clip to make everything look greener, which helps to complete the impression of a glowing screen.

# Wall Projections

You can project video footage onto a wall to create a variety of unusual effects, including fake windows. This enables you to create the illusion that a windowless location in the city actually looks out onto a forest scene.

The technique can also be used to create unusual and surreal lighting effects. In all cases, care must be taken to position your actor so that the projected image hits the wall and not the actor, or the trick will be revealed.

**1** To create a fake window, shoot a real window looking out onto an open space. This window has been lit from the side, helping to create the impression that the window is in a real environment.

**2** Export your video footage to a VHS tape and connect your VCR to the video projector. Position the video projector so that the image can be cast onto a blank wall.

**3** The less detail or patterning there is on the wall, the better. Try to use a wall that is as blank as a projection screen, and you'll get the best results.

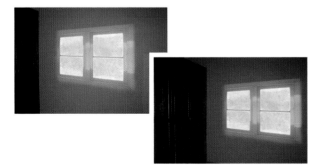

**4** The beauty of this effect is that you can move the camera during the shot, as shown here. If you were to add the window in post-production, you would have to shoot with a static camera. To complete this shot, you should have one or more actors in the foreground.

**5** To create a surreal effect, shoot footage of an outdoor cityscape and project it onto your wall. If you want this to look like pure lighting rather than an image, you can project it out-of-focus. This creates the impression that the room is lit by many tiny, colored lights.

# Shadows on the Wall

Popular in horror movies such as Murnau's classic *Nosferatu*, a large, sharply defined, creeping shadow is something that can make a scene both chilling and powerful. With a little planning, and careful positioning of your movie light and actor, this effect is easy to create.

It's often said that what you can't see is more frightening and compelling than what you can. A shadow on the wall suggests the presence of someone approaching without giving everything away at once.

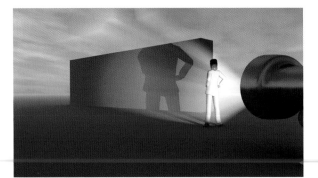

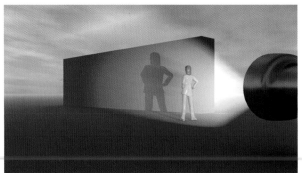

**1** Your light should be positioned far enough away from the wall that its beam reaches from the floor to the top of the wall. If you are using a movie light that can be focused, widen the beam as far as possible. When you position your actor close to the light, the shadow will more than fill the wall space.

**2** Try varying the effect. Leave your light in the same place, but move your actor toward the wall to make the shadow smaller.

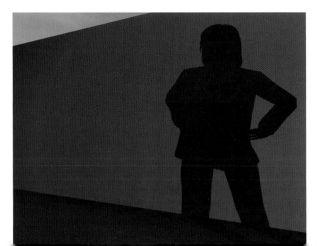

**3** Position your camera to shoot the shadow without shooting the actor. Rehearse the entire scene to make sure the actor's shadow can be seen on the wall, without the actor actually appearing or the camera casting a shadow on the wall.

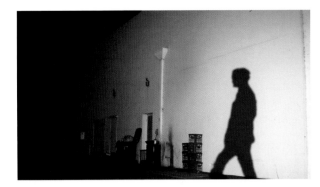

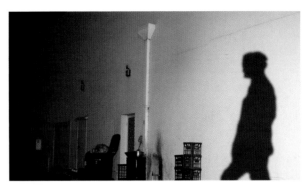

**4** While this shot captures the basic effect, the shadow of the actor's legs on the floor spoils the image, because they draw the audience's attention to the right edge of the frame, as they try to catch a glimpse of the actor.

**5** The same shot can be framed so that all we see is the shadow on the wall, rather than the shadow on the floor. This focuses the audience's attention on the shadow itself.

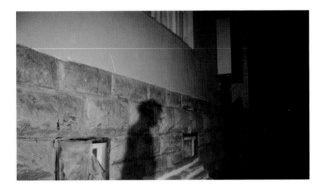

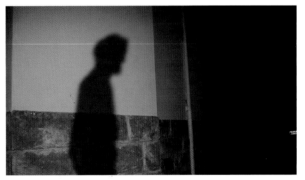

**6** Be wary of casting a shadow on a wall that has too much detail or patterning, or that has brightly lit windows; this will obscure the effect of the shadow.

**7** While not completely blank, this wall is better because the shadows show up cleanly and clearly.

**8** To make the most of your shadows, get your actor to move forward so the shadow appears to slide across the wall. The shadow will grow larger as your actor moves, which will add to the sense of menace you want to achieve.

# Time Travel without an actor

You can make it appear that time is passing at great speed by showing, for example, objects whizzing past, fruit or vegetables decaying, or day and night passing in seconds (remember *The Time Machine*?). No special equipment is required, but you must have lots of patience, as it takes a long time to capture all the footage you need.

Sequences such as these can be used to depict either a supernatural event or simply to show time passing. Rather than using a screen caption saying "Three Weeks Later," you can represent it with a memorable image.

 **1** Set your camera up on a tripod, and point it at something that will change in a visual way as time passes, such as a clock. Even on Long Play, you will only get 90 minutes of footage from a DV tape, so this technique only works for showing the rapid passage of an hour and a half. However, if your DV camera has a time-lapse function, it will capture images in two- to four-frame bursts, which can be cross-blended in the edit, later on, to reveal far longer periods of time.

 **2** If you shoot toward sunset, you can capture the light changes that occur during an hour and a half. This will make the visuals all the more impressive.

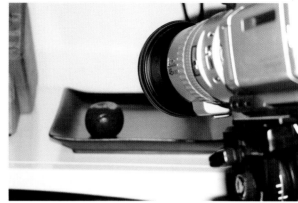

**3** Load the entire clip into your software, and change the Speed setting until the clip is just a few seconds long. If there is a Frame Blending option, switch it on—this will make the rush of images smooth and seamless. The result is that an hour and a half will seem to flash by in a few seconds.

**4** If you want to show more time passing—over days and weeks— you'll need to set up your camera and leave it in position for the entire shoot. Rotting fruit is an ideal subject to show time passing—it only takes a few days in warm climates for it to rot completely. When you set this up, make sure it is evenly and consistently lit, preferably in a room where there is no sunlight. Light the fruit with a tungsten lamp, which will also facilitate the decaying process. If your camera has remote control, use it. Never touch the camera and lock off pan and tilt functions.

**5** At the same time each day, shoot ten seconds of footage. Leave the exposure on automatic, so the lighting looks the same, even if the lighting conditions are slightly different from day to day. This will create the impression that time is passing rapidly, without a change in lighting. Alternatively, if you want to show day and night passing, you can take ten seconds of footage every two or three hours to show the light changing.

**6** Join all the clips together, and, if necessary, use Color Correction filters to match them more accurately. Apply a Cross Dissolve transition between each clip. Export the finished sequence as a clip. Import the clip you've just created, and change the Speed setting to 700 percent or higher. It should now look as though the fruit rots in a matter of seconds.

# Time Travel with an actor

This is an advanced version of the time-travel effect, in which your actor travels through time unchanged, while the world speeds by. The illusion is that your actor moves at a normal pace, while time advances around her.

This technique is used frequently in music videos, and has been used in films such as the independent movie *Garden State*, as a way to show the character's almost trance-like remove from the world. Although it looks like a complicated special effect, the main trick is to get your actor to sit still.

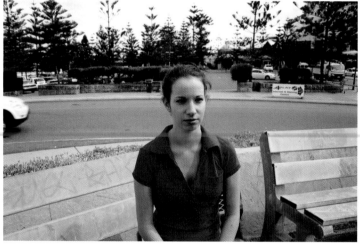

**2** You'll need a steady tripod to keep the camera motionless while you shoot. Position your actor, then set the lens as wide as possible so that the camera takes in more of the background. Get your actor to sit completely still, and start shooting. Keep shooting for several minutes. It's a good idea to give the actor something to silently repeat over and over again in his or her head, which can help them to maintain a consistent expression.

**1** Plan to shoot in a location where you won't be disturbed or approached by passers-by. However, you also need a location where there is plenty going on in the background. If you shoot in a deserted park and nothing happens in the background, the technique won't work.

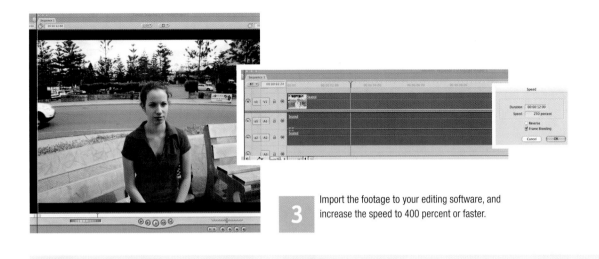

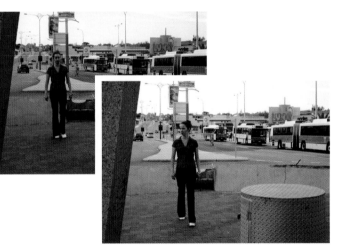

**3** Import the footage to your editing software, and increase the speed to 400 percent or faster.

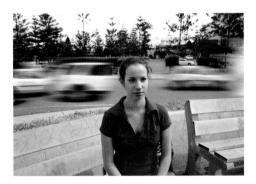

**4** If your actor remains still, she will appear motionless as the world rushes by in a flickering blur. You may find that your actor twitches in some sections, or there may not be enough background motion at other times. This is why it's a good idea to shoot for five minutes. Somewhere in there, you'll find enough good footage to create a shot that's several seconds long.

**5** For an interesting variation on this technique, have your actor walk slowly toward the camera. Your actor should walk incredibly slowly, while trying to make it look as smooth as possible. In this example, the walk took five minutes.

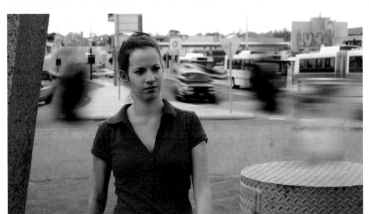

**6** Speed up the footage until your actor appears to be moving at a normal speed, with the background swirling around at a faster pace.

# NIGHT SHOOTS

# Parked Car

In a night scene, two characters sit and talk in a car parked at the side of a road. Although you can switch your camera to autoexposure, and get footage that looks fine in the viewfinder, the result will look awful on a full-sized screen. When it's too dark, the image becomes extremely grainy.

The answer is to put lights in the car, out of view of the camera, but bright enough to light the actors' faces. While real cars never have this much light inside, audiences are used to seeing this type of lighting in car shots.

**1** Park your car on private property at the edge of the road. This is much safer than actually parking in the road, and the audience won't know. Run electrical cables in through the back window.

**2** Position portable fluorescent strip lights below the actors by taping them to the car dashboard. These will throw light up at the actor's faces. While you work, it will help to have a bright external ("work") light on the car, so that you can see what you're doing. When you want to see how the effect looks, turn the work light off. This will make the body of the car invisible through the camera, but lets you see how well you've set up your lights.

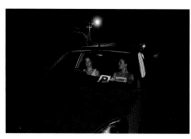

**3** At the beginning of your scene, an establishment shot is all you need to show that the characters have parked in a street. Here, a soft light has been thrown onto the body of the car to illuminate it just enough to identify the setting.

**4** You may be tempted to point your movie light into the car because it lights everything so clearly, but as this shot shows, the flares and reflections on the glass spoil the effect, and the brightness is not realistic. Always light from within.

**5** Place the camera on a tripod, and shoot the actors from straight ahead as they talk. The microphone wire should come through the rear window, with the mike placed out of the camera's view.

# Bluescreen Car

The bluescreen technique is an ideal solution for shooting car chases set in the daytime. It can also be used to shoot a more leisurely driving scene, and lets your actors concentrate on acting, without having to drive an actual car.

By setting up a small studio in a garage or other space, you can record good sound, get your lighting right, and add any moving background you want. It takes some time to set this shot up, but once you're rolling, you'll get lots of good footage quickly.

**1** Start by shooting the footage to use in the background. While someone else drives, shoot out of the driver-side rear window and the front windows, keeping the window frames out of the shot.

**2** To shoot the driving footage, first drape a piece of bluescreen material alongside the driver's window. Light the bluescreen with a fluorescent strip lamp, placed on the floor.

**3** Set up a movie light in front of the vehicle, to light your actor. Ideally, you should shoot this in a closed space, because outdoor light can interfere with the bluescreen effect. Better still, shoot at night.

**4** Check that your lighting doesn't cause unwanted reflections. Angle your lights to prevent this. You may even need to cover the walls with black cloth to prevent reflections from showing up.

**5** Shoot your actor's scene, and make sure he steers and reacts to the outdoor environment. If there's playback facility on set, the director can guide the actor to what's happening in the background footage and tell him what to do.

**6** Use the bluescreen technique to remove the bluescreen from the driving footage, and add the background footage. The result is convincing, especially if you frequently cut to other shots taken through the rear and front windows of the moving car.

# Rear Projection

If you want to shoot long dialog scenes in a car, you'll need to see both actors from the front. Although you can strap a camera to the front of the car and get the actors to go for a drive, this is dangerous and distracting for the actors. Unfortunately, the bluescreen technique doesn't look good from the front.

The solution is to set up a digital video projector to screen footage behind your actors. Variations on this technique have been around since the early days of film, but it remains in use on most films and TV shows.

**2** A thin bedsheet will suffice if you can't get hold of a translucent screen, so long as you have a video projector that is bright enough.

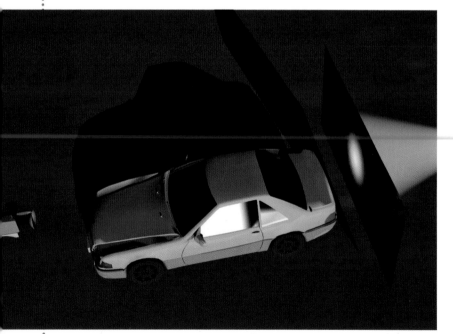

**1** The first thing you need to do is shoot the footage you are going to project. You'll need to shoot it through the rear window of a moving car. Don't forget to blur the projected footage slightly, otherwise it will look unrealistically sharp. Next, rent a digital video projector and a translucent screen. This enables you to project moving images onto a screen set up behind the car. You can use your own VCR attached to the projector. Put the transparent screen behind the car, and put the projector behind the screen. Set the camera up in front of the car, pointing straight at the windshield.

**3** Use fluorescent striplights inside the car to light your actors. You'll use this technique whenever you're shooting actors in a car at night (see Parked Car, page 152).

**4** If you're in a confined space and don't have room to put the projector behind the screen, you can place it on top of the car. It will never be in shot, so it's fine to leave it up there. You may need to angle it down to get a full projection on the screen. Tape the projector to the car to prevent it from falling off.

**5** While shooting, if the projector is not sitting on the car, have someone gently rock the car. (If the projector is on the car while it's rocking, the projected footage seen through the back window will move with the car, which will destroy the illusion.) The rocking motion will barely be visible, but it makes the actors move slightly in response. Although it's a tiny detail, it adds realism and helps the foreground match what's being projected behind.

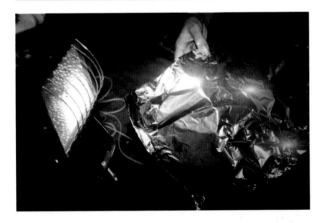

**6** Position assistants in front of the car with silver foil, lights, and torches to cast light onto the front windshield. By angling these lights carefully, you can make it appear that glowing dabs of light are sliding up the screen. When a real car drives at night, this is the effect you get—streetlights slide up the screen. This exact technique is used on many major films, so don't underestimate how important it can be as a finishing touch.

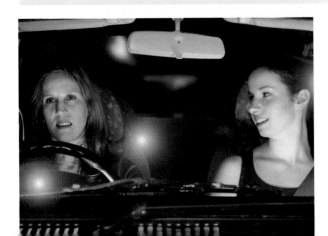

**7** You can now shoot a long scene, capturing high-quality sound, and the audience will be totally convinced that it was filmed in a real street.

# Rain Car Shot

This classic Hollywood shot, in which a character drives at night in the rain, can be achieved safely without even moving the car. It does take time to set up, but the results are so powerful and atmospheric, it's well worth the effort.

The setup shown here is for shooting the driver only. To shoot the passenger, you simply reverse the setup and record the scene again. You can then cut between the two angles as the characters talk. Use a simple garden hose to create the sound of rain.

 Before you set up the camera and projector, test the water spray on the car. Make sure that it falls well short of the electrical equipment and cables. Place a projection screen close to the driver's window.

 To create the background footage, shoot out of the side window at night, in a brightly lit street. Make sure the footage is bright, otherwise it won't show up well through the artificial rain.

3 Wind down the rear passenger window on the left side, to give you a clear view of the driver. You'll also need to cheat slightly by moving the passenger seat out of the way.

 This is the line of sight you are trying to create. It's a straight line through the open rear window, with a clear view of the driver, to the projector screen through the front and side windows.

5 When the actor is in place, and lit from below, zoom in so that the camera seems to be in the back seat. The outside of the car shouldn't be in shot at all. The other actor can sit immediately behind the driver, in order to run through the dialog.

 To create the rain, spray a garden hose over the front of the car, and ask the actor to turn on the windshield wipers. To complete the effect, start the projector with the background footage and have someone gently rock the car.

# Lighting in a Street

When you shoot in dark places, there are two things you want to avoid. The worst of these is underexposure (where everything looks too dark) and the other is autoexposure in low light (where everything looks bright but grainy).

To get good lighting in a street at night, you'll need to light your actors artificially. By doing this, the street shows up clearly, with the actor well lit in the foreground.

**1** When you leave the camera on autoexposure, it will capture an image for you, but when displayed on a large screen, the image will look coarse and grainy. So, don't trust your eyes when shooting at night.

**2** The opposite problem occurs if you use manual exposure and close the iris down to prevent grain. There simply isn't enough light for this scene, so when you get rid of the grain, you get rid of the image.

**3** Set up a large movie light in front of the actor. To get the lit-street look, use something to soften the harsh glare of the light. You can use baking parchment or a photographer's light-softener.

**4** When lighting the actor, be careful not to let the background vanish into complete darkness.

**5** Instead, adjust the camera's manual exposure settings until the actor can be seen clearly, with the street showing in the background. The more familiar you are with your camera's manual controls before you go outside, the easier this will be.

**6** When shooting close-ups, no matter how well exposed the scene is, you may find there is only darkness behind the actor. If so, change your angle so that a brightly lit feature, such as a streetlight, is clearly in frame.

# Creating Moonlight in a Forest

Shooting at night in a forest presents you with a variety of challenges. While you want to capture the realism of nighttime, you don't want your images to be too dark.

For decades, moonlight has been represented in movies as a bright, hard light that makes everything clearly visible. Although this is a long way from being realistic, it's what the audience expects to see. In fact, if you shoot in real moonlight, the limitations of your DV camera will make it look less realistic than a brightly lit setup.

**1** First of all, let the audience know that the next scene takes place on a moonlit night in the trees. As well as showing the moon and trees, use sound recordings of the forest at night to begin building the atmosphere.

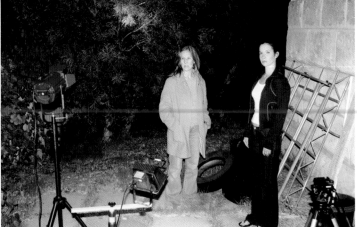

**2** In this example, we aren't anywhere near the forest at all, but shooting outside a warehouse. This is because it's far easier to plug in lights and cameras when there are electric sockets nearby. While you can take a generator out to a real forest, it makes a lot of noise, which will spoil your dialog.

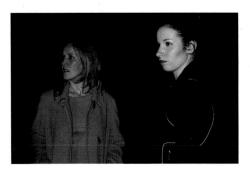

**3** This shot was filmed with the most basic lighting setup, and the actors are barely illuminated. Although this will look realistic to you while you're shooting, it won't look good when it's on screen. You need more light than this.

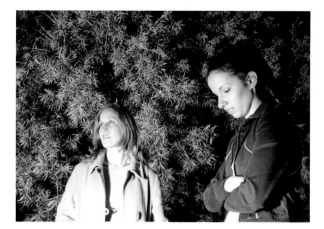

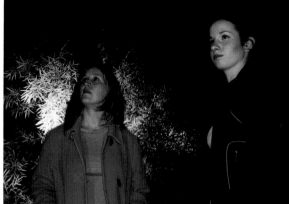

**4** Switch all of your available lights on, and point them at the trees and the actors. (When shooting indoors, you usually start with one light and keep adding lights until you have the look you want. When shooting outdoors, the opposite approach yields better results.) Start with all your lights, which will be too bright, then begin fading, narrowing, and pointing them away until you get a good look. To aid the effect, mount the lights as high as possible and angle them downward toward the actors.

**5** The final lighting setup has a bright, hard light on the background tree, with the actors clearly lit in the foreground. When shooting, you have to imagine how this shot will look in the finished sequence. On set, it will look completely unrealistic, but you have to trust that this is the way moonlight is shot. A good recent reference for brightly lit nighttime scenes is *The Fellowship of the Ring*, if you want to see how it's done by the professionals.

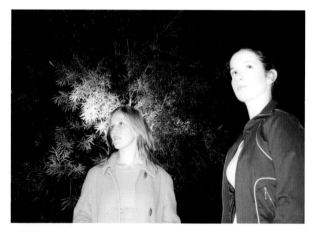

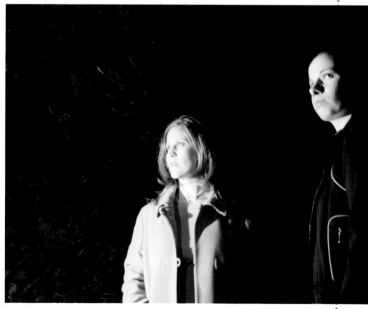

**6** When you load the footage into your software, create the moonlit look by using the Color Correction filter to shift the hue toward blue and to desaturate the image slightly.

**7** An alternative lighting setup involves pointing the brightest light at the actors and using a dimmer light on the trees. This is best if you're trying to show an approaching car or spaceship, or if the characters are meant to be standing outside a window.

# Faking Night Shots Indoors

Shooting at night is normally required at some point during a movie shoot. But working at night is difficult and tiring for everyone concerned, so it's best to fake nighttime and shoot during the day. If you are using amateur actors, they'll appreciate a schedule that suits them, and if you are using pros, the day rate is cheaper than the night rate.

To fake the effect of night during the day, you will have to black out your interiors, but as long as the shots look convincing, the quality of your scene won't be affected.

**1** Use a room with as few windows as possible. If your room is going to take more than ten minutes to black out, it might be best, if you can, to find a darker place to shoot.

**2** Start your work on blacking out the room by closing all available blinds and curtains. Screen the windows as much as possible.

**3** Use electrical tape to secure black material over your window. The material doesn't need to be particularly heavy, but use material that lets as little light through as possible.

**4** Tape the edges of the material down to ensure that it is secure from any potential drafts.

**5** Even small amounts of stray light from outdoors can affect the realism of these shots, because if your camera is set up to record tungsten light, daylight shows up as blue. You can prevent light coming in under the door by forcing a towel into the gap.

**6** You can now light the room exactly as you would if you were really shooting at night, and the audience will never suspect that you shot this scene during the day.

# Faking Night Shots Outdoors

If you want to shoot twilight or create a basic impression of night, this technique shows you how to create a moonlit look in the daytime. You can shoot twilight scenes at sundown, but the light changes so quickly that you'll have difficulty editing the scene. Also, you will find that real twilight is usually too dark to shoot convincingly and your footage will look grainy.

This technique works well if you are trying to create a dusky, twilight mood. These fake night shots are an ideal transition between daytime and nighttime scenes. For shots that are meant to take place in the dead of night, you should try to shoot at night.

**1** Color correction is the key to faking nighttime shots in the day. You shoot a scene, even in bright sunlight, then use your software to make it look bluer. Be wary, though, of shooting the sky. As this image shows, when the sky is in view, no amount of color correction will help. It just looks like a blue shot of a sunlit day. For this technique to work, you must keep the sky out of the scene. To aid the effect, use a neutral density filter on your lens to reduce light levels further.

**2** One way to keep the sky out of your shots is to place the camera high above the actor, and point it downward, so that the horizon is above the top of the frame.

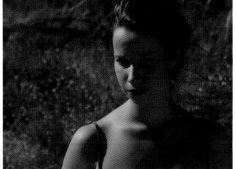

**3** Import this footage into your software, and use the Color Correction filter. You should aim to reduce the overall saturation of the colors, and to shift the colors toward blue, but do not try to darken the image. If you make the image too dark, it will only look like badly shot footage. You'll find that some shots look better when the contrast is lowered, whereas others are more realistic when it is raised slightly.

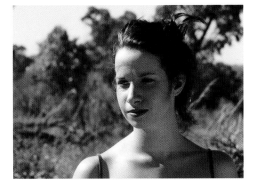

**4** You don't want to take every shot pointing down a hill, so take a sturdy ladder with you. Get somebody to hold the ladder, and go up a couple of steps to angle the camera so that even close-ups are free of sky.

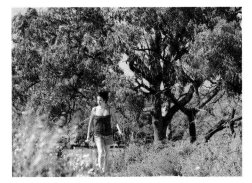

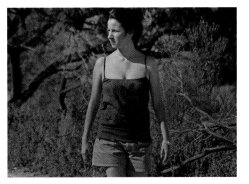

**5** If it's impossible to get higher than the actor, stand a long away back, and zoom in. This reduces the amount of background visible around the actor, thereby effectively cutting the sky out of frame.

# WEATHER

Movie Rain
Fake Snow
Fall Wind
Desert Sun
Storms

# Movie Rain

Real rain doesn't show up very well on film or video, so you need to create your own. This technique shows you how to use nothing more than a hose and a light to safely create your own rain machine.

In this example, we shot at night, but you can just as easily create this illusion in the daytime. Instead of lighting the rain, you use the sun as the main backlight. You are not trying to create realistic rain. You are trying to create a representation of rain that's visible on screen. While you're shooting, you may think this rain looks unrealistic, but it will convince your audience.

**2** You don't need a rain machine to create rain. Instead, you can use an ordinary garden hose aimed at a point above the actor's head. Make sure your rain doesn't come in from the side, but from above. To achieve this, aim the hose at an object above the actor. Here, the leaves and wood act as a perfect target for the hose. If there's nothing in the scene that will work, position a piece of wire netting above the actor.

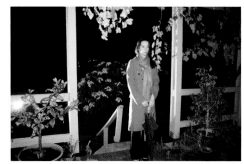

**1** In this scene, the light is placed many yards away so that no water can get anywhere near it or the cables. To light the rain properly, your main light must be in front of the camera, and pointing toward you. You will set up your camera so that the light is out of shot, but the light must come toward the camera. The glowing leaves are a good indication that this lighting setup is correct. If they glow strongly against the dark background, so will the rain.

**3** Make sure that the lighting on your actor is as good as the lighting you've set up for the rain. It's easy to get carried away with lighting the rain to great effect, but take the same care to light your actor well.

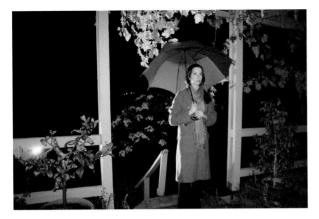

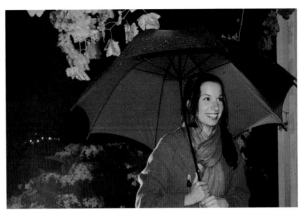

**4** Before you begin shooting, talk through the procedure with your crew, and rehearse a couple of times without the water. You'll be tempted to get on with the rain, but you are guaranteed to get better results if you pause for a rehearsal.

**5** Set your tape rolling, get the hose going, and wait a few moments. The rain will not fall realistically at first, so give it a few seconds before calling "Action!" A good tip is to have your assistant place his or her thumb over the end of the hose to direct the water in a wide arc. The effect will be much more realistic. A showerhead or grille-style watering-can spout can also be effective.

**6** As you play out the scene, the person holding the hose should keep it as still as possible, so the glowing rain appears to be falling from the sky. You may be concerned that there's no rain falling in the distance, but nobody in the audience will notice.

**7** A different and more mysterious look can be created by taking all the light off your actor, throwing her into silhouette against the rain. This doesn't work for all scenes, but keep it in mind because it can look quite dramatic.

# Fake Snow

Fake snow is easy to create as long as you only want to show a few glimpses to set the scene. If you want to shoot a long walking scene, you'll run into great difficulties, because you can only fake snow in a contained area.

The best way to fake snow is to shoot short scenes in small areas. You can shoot the rest of the scene with the camera down low, looking up at the actors, to avoid showing the ground. Once the audience has been introduced to the idea of a snowy scene, the suggestion will remain in the audience's mind throughout the remainder of the scene.

**2** As an alternative to flour, white towels can be placed in bright sunshine to create a snowy backdrop for a close-up. Ruffle up the towels to create realistic texture.

**1** One of the easiest ways to imply that snow has fallen is to create a brief establishment shot. Here, flour has been sprinkled onto the garden equipment, and this looks sufficiently like a soft snowfall to convince the audience. Having established this, you could cut to an indoor scene, and the audience will believe it has been snowing outside.

**3** Shoot your close-up in front of the towels. In this shot, a fisherman is tying up a boat after snow has fallen. This shot, combined with the sound effect of wind whistling past and appropriate costuming, will convince an audience of the presence of snow. You must use a long lens, however, to ensure that the towels are out of focus.

**4** To create a snowfall you'll need to find a shallow cardboard box long enough to stretch across the width of a window. Cut a slit along one edge of the box for the snow to fall through.

**5** To create your snow, use dried potato flakes or tissue paper torn into tiny shreds. You don't need the shapes to be regular because the snow will just look like blurred light when filmed.

**6** Shake the box of snow in front of a dark background, and make sure it is well lit. You get the best results if the snow is slightly out of focus. Here, we focus on the actor's reflection, as the snow drifts down in the background. Be careful to shake the snow realistically—if you are too vigorous, it will look fake.

**7** You can also superimpose snowfall onto a scene by first filming snow against a completely black background. In your editing software, layer the snow footage over the scene to which you want to add the falling snow, setting the Composite Mode to Screen. This can only be used to imply that snow has started to fall, of course, because there won't be any snow on the ground.

# Fall Wind

There's something very atmospheric about a leafy fall backdrop. Imagine all those movies set in New York in autumn without the leaves falling from the trees in Central Park. You can create the illusion of a cold, fall day, with leaves blowing on the breeze. The scene shown in this example was shot in the middle of a baking hot summer, but looks convincingly chilly.

Although the main techniques involve blowing leaves and careful choice of shots, don't forget the power of sound. Record the sound of leaves scraping on the ground or being crushed underfoot to project the unmistakable atmosphere of Fall.

**1** If you're shooting in fall, all you need to do is find a location with the appropriate trees, and the shot is virtually complete. If you're shooting in a different season, look for out-of-season trees.

**2** These trees, shot in summer, looked reasonably suitable. The effect was enhanced by importing the footage into the editing software, and using the Color Correction filter to increase the red and yellow.

**3** To simulate a fall wind, you need leaves. Dry leaves are perfect, because they indicate fall and breeze at the same time. You should be able to find some dead leaves and dry them out.

**4** Get two assistants to hold a leaf blower and drop leaves in front of it. The sound recorded during this scene will be unusable due to the noise of the blower, so you'll need to re-record the sound of footsteps and leaves, and add them in later.

**5** Rather than having the leaves fall and blow all around your actor, show her feet with the leaves skittering past. This way, you only need to show a brief amount of leaf movement. The rest of the scene can be played out without seeing a single leaf.

**6** Either bright sunlight or overcast skies are fine, because both occur naturally in autumn. And you might get lucky and shoot on a windy day, but, if not, be sure to shoot some footage of the wind machine blowing gently on the actor's hair.

# Desert Sun

Whatever the weather, you can create the illusion of harsh desert sunshine. You'll need to apply different techniques according to the weather you're shooting in, but the end result will create the right impression.

Most of the time you'll need to shoot from below the actor, looking upward into the sky, otherwise you'll give away the fact that you're not in the desert. This does mean, however, that you can simulate the desert sun in your back garden.

**1** If you're blessed with a sunny day, position your actor in front of the sun so that she is almost in silhouette.

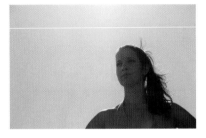

**2** Move closer or zoom in so that the sun's glare is no longer in shot. Adjust the exposure so that details in the actor's face are visible. This makes the blue sky brighter and puts a gentle glow in her hair.

**3** On a day that offers a mix of cloud and sunshine, you can create the right look by leaving harsh shadows on the actor's face. Adjust the exposure so that the shadows look as bright as normal skin.

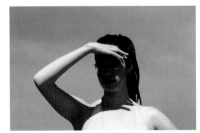

**4** On a dull day, you'll need to angle an artificial light down toward your actor, to simulate the sun. The actor is standing in front of a dull sky, but the light casts hard shadows. This, combined with her costume, makes the scene convincing.

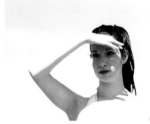

**5** Adjust the exposure so the shadowed areas of the actor's face appear to be normally lit—everything will brighten dramatically. Although some detail is lost from her clothing, the gray sky now looks like the glaring overcast sky that you find in the desert.

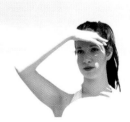

**6** The final touches can be achieved in post-production by using effects filters to alter the color. People often report that colors look unnatural to them when they've been out in the sun for a long time, so you can make the sky look slightly purple.

171

# Storms

When you plan to shoot a storm, you can't afford to wait for the weather to do what you want. Instead, you must simulate hard rain, flashes of lightning, and even a view of forked lightning in the distance.

The easiest way to simulate a storm is to shoot in a room with closed curtains and add sound effects. Although it works well enough, it isn't as good to look at as rain and lightning. If you want to see your character watching the storm and responding to its power, use this technique to make the storm fully visible on screen.

**1** Position your light outside the window of the room where you'll be shooting, keeping the electrical cables up off the floor, and far away from the water.

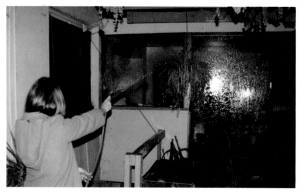

**2** The setup is similar to that of creating movie rain in that a light should be pointed toward the actor and the camera. The rain is supplied by a hose directed at the top of the window.

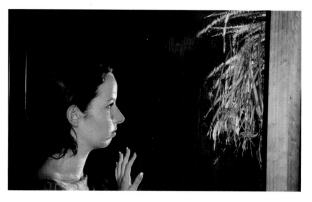

**3** From inside, the rain appears to trickle down the glass as the actor stares out at the storm. Here, the actor is also lit from inside, so we can see her expression clearly.

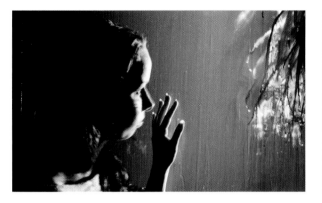

**4** With more water and more spray, you get a stronger, more convincing, movie-rain look. This works particularly well if there's no light inside. The character is lit only from the exterior glow of simulated streetlight. If you want to shoot your lightning flashes on set, several strong electronic flashguns, fired in quick succession, create a good simulation of this effect.

**5** It is sometimes easier to simulate lightning in your editing software. First, you need to load the clip. Apply a Brightness filter, and set it to 150 percent. A frame or two later, reduce the brightness to 100 percent. This will make the image flash, as though there's lightning outside. Sound effects are essential for this to work. The sound of thunder should follow just a moment after lightning.

**6** If you want to show lightning as seen by the character, draw several forks of lightning on a piece of white card. Photograph or film the drawing, and import the image to your timeline.

**7** In your editing software, add the lightning over a wide shot of the landscape. Change the blending mode to Add, and use the Color Correction filter to make the lightning appear blue. Each fork of lighting should appear for just one or two frames. You can also apply a Lens Flare filter to one frame, to add a flash of brightness in the middle of the lightning. Sound effects complete the illusion.

# SOUND

Impact Sounds
Off-screen Sounds
Science Fiction Sounds
Atmosphere

# Impact Sounds

No matter how good your film looks, it needs to sound right if you really want to "wow" your audience. It's well known in the directing community that sound is as important as vision, and that without good-quality sound, a film can't work effectively.

Rather than relying on the sounds you record on set, you can record sound separately and then add the sound clips to your finished film. When you shoot a fight scene—a violent stabbing, for example—additional sound recording is an essential finishing touch.

**1** Use the best microphone you can afford, preferably with a boom-pole, and record your sounds in a room without too much reverberation. Make sure you turn off any electrical equipment.

**2** Wear headphones while you record sound, so you can hear exactly what is being recorded. Earphones cover your whole ear and are better than headphones, because they cut out more external noise.

**3** To create the sound of somebody being stabbed, thrust a knife into a piece of fruit. Apples create a crunchy sound, and cabbages also sound like an authentic knife thrust.

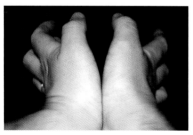

**4** To create the sound of a punch, clap the heels of your hands together. This slapping sound is realistic, but many filmmakers prefer a louder, less realistic sound. If you want to create Hollywood-style punching sounds, try recording a slamming car door.

**5** The sound of rustling clothes is important for building the sound of your fight scene. Watch your completed footage, and try to move as the actors move, with the microphone close to your body to record the sound of your clothes moving.

**6** Load the sounds into your software, and adjust their positions until they match every punch and slap. It takes many layers of sound to create a realistic sequence, but it's worth it. A gentle punch with a suitably "punchy" sound suddenly seems brutal.

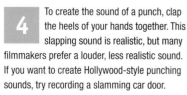

# Off-screen Sounds

As a director, you can save a lot of time and money with the clever use of sound. You can use sound to imply something has happened, without actually filming it.

It's a psychological phenomenon that directors put to great use. When people hear a sound such as breaking glass, and then see a broken window, they think they remember seeing the glass being smashed, when, in fact, they just heard it off screen.

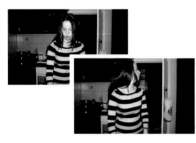

**1** In this scene, the character is alone in her house, and hears a noise outside. She turns and reacts. This is the simplest form of off-screen sound, but one of the most effective.

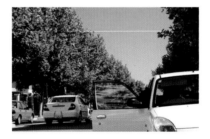

**2** For this sequence, we want a robber to break into the main character's car. The shot begins with the actor leaving her car, giving us a clear view of the window that's about to be broken.

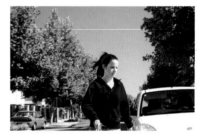

**3** We now follow the character as she walks away from the car. We want this shot to be familiar when it is shown again or the audience might think she's looking at somebody else's car.

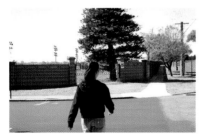

**4** Pan with the actor as she walks past the camera. This establishes that her back is now to the car. The audience will have picked this up subconsciously and should now be absolutely certain that she has left her car, and that it is behind her.

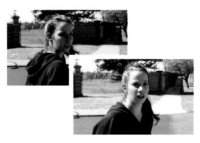

**5** Cut to a close-up as she hears and reacts to the sound of breaking glass (which can be recorded later).

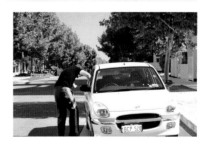

**6** Cut back to the car a moment later, where the robber is apparently clearing broken glass from the window and reaching inside. You must cut to this shot quickly for the effect to work. Your audience will think they saw the window being smashed.

# Science-fiction Sounds

A sci-fi movie isn't a sci-fi movie unless the battle scenes feature the sound of a thousand laser guns going off, the strange languages of alien species, and the roar of spacecraft engines. Thankfully, these sounds don't need to be synthesized electronically, but can be created by recording ordinary, everyday sounds.

By mixing and blending the sounds of humming TVs, wild animals, and kitchen appliances in your editing software, and applying audio filters, you can make complex science-fiction sounds. This approach has been used on every science-fiction film, including the *Star Wars* movies.

**1** Spaceship sounds can be created by mixing the sound of airplanes as they fly over, or taxis as they pass the camera. Airplanes are a good source of sound, because you can usually record them in an area where there are few other sounds. Position yourself near the runway (or as close as you can get without trespassing or endangering yourself), to capture the changing pitch of the airplane as it passes overhead. When you apply this sound to your spaceship footage, you should time the change in pitch to match the moment when the ship passes closest to the screen. You can do this by capturing the image of the airplane as well as the sound, and synching the clips up visually. You will find the airplane sound is too recognizable, so apply a filter such as Delay to make an original sound.

**2** Aliens and robots can be made to sound as though they are talking in their own language by combining nature sounds. Record birdsong or zoo animal sounds and combine them in your editing software. Cut each sound into small clips and rearrange them to give each sound the rhythm of a word. Apply filters, such as Graphic Equalizer, to change the tone of these sounds, so they are less recognizable. There are no hard-and-fast rules other than to experiment.

**3** Laser bolt sounds can be created by banging ordinary household objects together. Record the sound of metal against hollow plastic, and metal on metal. Import these sounds into your footage, speed them up by about 400 percent, and combine them. Add Echo filters, and you will find that the natural resonance of these clips sounds like a movie laser bolt. For a more sustained laser, you can slow the sounds down by 400 percent to make them hum and hiss.

# Atmosphere

When you record dialog, you try to cut out as much background sound as possible. This makes it easy to edit dialog together. The downside of this is that you don't capture any of the background atmosphere. For a scene to sound real, there should always be an additional layer of atmosphere.

If you're shooting a scene in a supposedly busy bar, but using only four or five people, you can record the sound of a real bar to bring it to life. This sort of atmosphere is vital if you want your scene to seem authentic. The audience won't notice the sound, but they will certainly notice if it isn't there.

**1** Whenever you shoot a scene, try to find the time to enact the entire scene without dialog. During this run-through, position your boom microphone so that you can record all the footsteps, rustling clothes, and banging doors. This sound can then be added as a layer of pure background atmosphere to your finished scene. You will need to cut and adjust the clip to match the visuals in your film.

**2** If your film is set in a still room with no movement, it's still worth recording the background sound. Even if you can't actually hear any particular sound, you will record what is known as the "room tone" or "buzz track." Every room you record in has a sound quality, and this will be present in all your dialog. By layering a clip of room tone under the dialog, you help the dialog blend together, without any audible cuts.

**3** Street scenes require the sound of traffic, even though you may need to turn it down so it is barely audible. Try to record your traffic sound somewhere where there are few pedestrians, so that passing conversation doesn't bleed into the final mix.

**4** Be on the lookout for unusual sounds that might suit your film. Here, a bank of air conditioners gave off a prominent, throbbing hum, which might be ideal for a scene set in an elevator or a factory.

**5** Record the sound of a waterfall, and slow the sound down to 20 percent of the original speed. This creates a soft, low hum, which is ideal for really quiet scenes. It can add a little warmth to scenes that feel a bit too clinical.

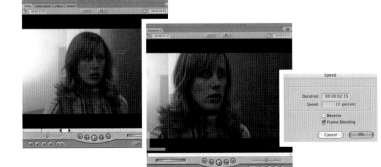

**6** Whatever sounds you record, this should be the first trick that you try: create a good background atmosphere by slowing an audio clip down and lowering the volume slightly.

# MAKE UP

Aging
Youth
Bruising
Serious Injuries
Illness and Disease

# Aging

There are quick and inexpensive ways to make young people look much older on camera. Sometimes you need a scene at the end of your movie which shows a character who has aged. Or you might want to flash-forward to a possible future for your character. This was used to good effect in the *Back to the Future* movies, for example.

This simple makeup technique is best for short scenes, rather than an entire film. If you want to create the illusion for just a few shots, this approach is more than adequate.

**1** If you're using a male actor, encourage him to grow a beard for these shots. This should immediately add a few years to his apparent age.

**2** Although foundation makeup tends to cover up blemishes, you should still apply a basic foundation, because it helps the rest of your aging makeup show up better on camera.

**3** Anywhere that shadows or lines are formed, such as on the forehead, under the eyes, or from the nose to the mouth, use dark smears of makeup to make the shadows stand out.

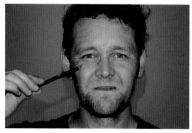

**4** Use an eyebrow pencil to draw dark lines into the actor's facial lines. Don't draw new lines, but fill in any folds or lines that are created when the actor screws up his face. Be subtle with your work—the effect should be as realistic as possible.

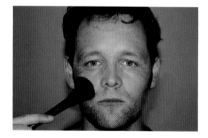

**5** A light dusting of finishing powder will help to keep your makeup in place, even under hot lights.

**6** Create the illusion of graying hair by dusting flour on your fingers, and running them through the actor's hair. In this example, we have tried to age the actor as much as possible, but you generally get better results with a subtle amount of graying.

# Youth

Many films require actors to look younger than they actually are. There are many ways to achieve this, but one technique is to get your actor to perform as though she or he is younger. One technique is to have your actor use a higher, less mature vocal pitch.

When you cut to a scene in which the character is suddenly much younger, you can use dialog or a caption on the screen saying, for example, "Ten Years Earlier," to emphasize the flashback. You can also accentuate the change with makeup and costume.

**1** Costume, makeup, and hair make an enormous difference to your actor's appearance. The actor doesn't necessarily look much younger in the second shot, but she looks different.

**2** Try making your actor look older just before you cut to the youthful scene. Here, the actor has relaxed her face muscles and reduced her makeup to accentuate her age. She is also shot from below.

**3** Here, the actor is shot from high up, so that when she looks up, the whites of her eyes are more apparent. This wide-eyed look adds to a character's youthful appearance, as do the costume and hairstyle.

**4** If you want to do a close-up, zoom in with a long lens rather than taking the camera closer. Long lenses flatter the face, and make subjects look more attractive.

**5** You can go even further by adding a slight "glow," as shown in the Filters exercise (see page 103). This effect can soften the signs of aging.

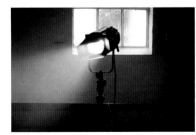

**6** When you want to age your character, use direct or "hard" light full of shadows, which emphasizes any wrinkles. When you want a character to look younger, use soft light reflected off a nearby wall, so that it disguises wrinkles and blemishes.

# Bruising

Fight scenes are integral to many of today's blockbuster movies. Thus, following a major fight scene, it is disappointing for an audience—as well as unrealistic—if your actor shows none of the signs of having been beaten up. A good bruise helps to remind us of the character's suffering, and can look extremely convincing when applied correctly.

Of course, a bruise can also help to fill in a gap in the story if the fight scene happened off camera. When somebody appears in a scene with a huge bruise, the other characters (and the audience) will immediately start imagining what has happened.

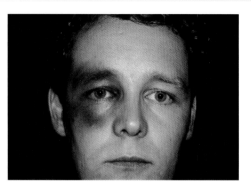

**2** To create a fresh bruise—the kind that might appear straight after a fight—use lots of dark red makeup. The make-up should be even darker on the bony parts of the face, around the eyes and where the cheekbones are most pronounced.

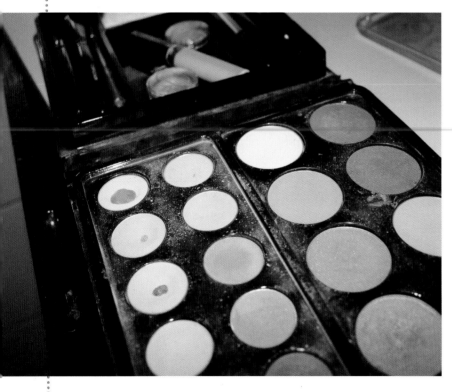

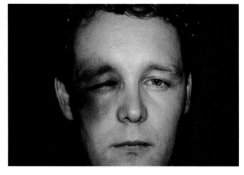

**3** If the sequence is meant to occur a few hours after the fight, you can get your actor to close one eye, as though the bruise has swollen. Your actor should do this in a relaxed manner, or it can look contrived.

**1** An ordinary makeup kit is all you need to create authentic bruises. Don't be afraid to use unusual mixes of color, because bruises are rarely black. A real bruise is a mixture of colors, including purple, yellow, and brown.

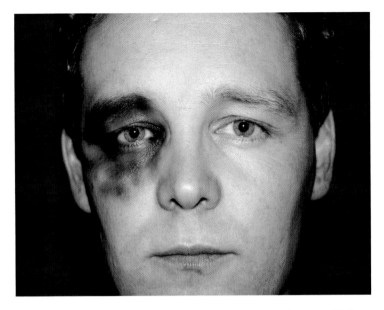

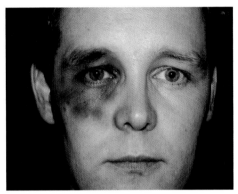

**4** When the bruise has aged a little more, add more blotches of purple and black. You don't need to be an expert with makeup, you just need the confidence to experiment, dabbing the makeup on in patches. Dark blobs in the corners of the eyes add a touch of realism.

**5** For a bruise that is supposed to be several days old, you should apply blotches of green or yellow. Make it look uneven to show that it is in the process of healing.

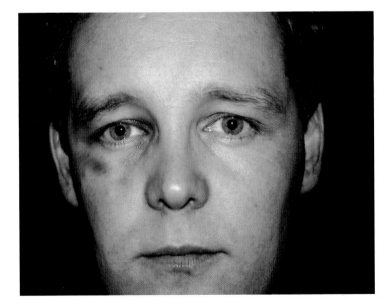

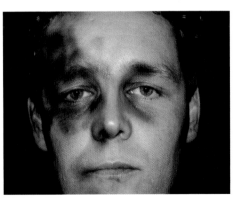

**6** If you're shooting a film that tracks an actor's life for several days after a fight, make sure you show the bruise fading away, rather than forgetting about it in later scenes. When the bruise has almost gone, it will be quite green with dark patches over the bone.

**7** If you want to show somebody bruised all over— perhaps following a more violent fight or a car accident—you can use the same techniques, but apply them over more of the face. In general, it's best to work on one side of the face only. You can darken the other eye socket, but keep the rest of the bruising on one side of the face, or it can look overdone.

# Serious Injuries

Broken bones, blood, and gore can all be made to look good on screen without the need for expensive equipment or makeup. These scenes should be shown for only a few seconds, so the audience can experience shock without studying the horrific scene in too much detail.

Don't be tempted to use animal offal in gory scenes. There are serious health issues, and offal soon begins to smell bad when put under hot lights. Also, despite being real, it doesn't look real on camera. Strangely, fake gore looks better than the real thing.

**1** To create the illusion of a broken leg, get your actor to sit or lie on the floor, with his knee bent comfortably away from his body. Perch his shoe on the end of his foot, pointing toward his back.

**2** Shoot this from an angle that keeps the foot hidden behind the shoe. This technique was used in *Blue Velvet*, and was famous for causing audience members to gasp in horror. Once you know how it is done, it looks fake, but this can really work for an audience.

**3** A good actor can bring a lot to the effect, as can the sound effect of the bone breaking. Record the sound of a twig being snapped, and edit this into the sequence as the cyclist falls. This sound, followed by the broken leg image, will convince the audience that the leg snapped.

**4** If you want to create the aftermath of a fatal head wound caused by a bullet impact, use the flesh of a fruit such as a plum. The inside of the fruit has veins and is textured like flesh. The dark skin is also good for simulating torn flesh and blood clots. Pile the shredded fruit onto the floor where you intend to shoot the scene.

**5** Just before you shoot, pour fake blood (made from red food coloring and glucose syrup) over the fruit mixture. Don't overdo it—you want this to look authentic.

**6** Position your actor so his head is over the simulated brains. A pale makeup can help to make the actor look dead. You can create the entry wound with dark black makeup, or by cutting out a circle of fruit skin and sticking it to the actor's forehead. The tiny red shreds of fruit around the skin help to make it look like a torn hole in the head.

# Illness and Disease

When your character is sick, a strong actor can convey the sickness through performance, but good makeup completes the job. It doesn't take long to add a few pimples or a layer of sweat, which can make a character look really unwell.

Always test the finished results under bright movie lights before continuing with your shoot. Makeup can look quite different on set, under with a strong light, so put aside time to do a complete check.

**1** If your character is suffering from a fever, you only need to make him look pale and sweaty. Whatever your actor's skin color, lighten it all over. Wet the hair, and spray water onto the face just before you shoot. Your actor should wipe the water around his face and eyes, but leave it in droplets on the forehead.

**2** For a more advanced illness, or to show somebody in the process of dying, you can add bruise-like colors around the eyes and temples. In addition, remove the light make-up from the eyelids themselves. This makes the natural skin color show through garishly, which adds to the impression of sickness.

**3** Another approach to sickness is to apply no makeup at all, except to the mouth. When an actor is filmed under bright light, it is extremely unflattering, and all the grease, blemishes, and discoloration in the face will show up. Even the most attractive people look quite unwell when lit brightly without makeup. By adding dabs of color to the edges of the mouth, you create the impression of somebody who has been sick so long that their lips have started to crack.

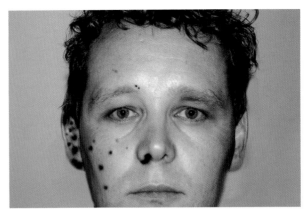

**4** Sores, blisters, and blemishes can be created by blotching dark makeup onto the skin. You can smudge this slightly around the edges. Don't put the pimples all over the face, unless your story really requires this, because too many pimples look unrealistic. Instead, put the blotches in the ears and coming out of the nose, to make it seem like a really intrusive disease.

**5** If you're creating a disease that causes the character's skin to peel from their hands, you can get the required result with wood glue. Find a quick-drying type, which goes clear when dry and is safe to use on the hands. Rub the glue on your actor's hands, let it dry for ten minutes, and then rub the hands together. The glue should flake off, looking like shreds of skin.

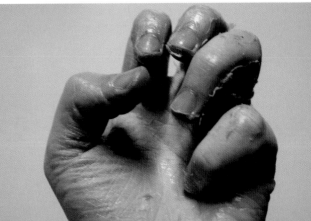

# Acknowledgments

Special thanks to Chantal Bourgault, Liz Cuffley, Claire Hooper, Matt Penny, Talei Howell-Price, Damon Lockwood, and Tabitha Kenworthy for their contributions.

Thanks to friends and family, as always, for their support.